Hugh Morton
North Carolina Photographer

Hugh Morton

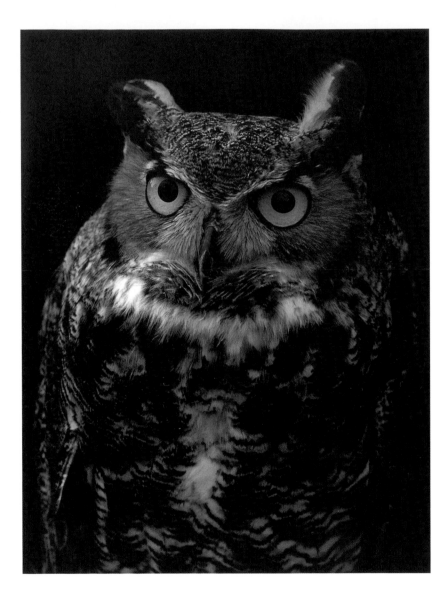

Foreword by

WILLIAM
FRIDAY

The University of

North Carolina Press

Chapel Hill

North Carolina
Photographer

Library of Congress
Cataloging-in-Publication Data
Morton, Hugh M.
Hugh Morton, North Carolina photographer /
foreword by William Friday.
 p. cm.
ISBN-13: 978-0-8078-3073-4 (cloth: alk. paper)
ISBN-10: 0-8078-3073-9 (cloth: alk. paper)
1. Nature photography — North Carolina.
2. Morton, Hugh M. 3. North Carolina —
Pictorial works. I. Title.
TR721.M69 2006
779'.309756—dc22 2006013878

cloth 10 09 08 07 06 5 4 3 2 1

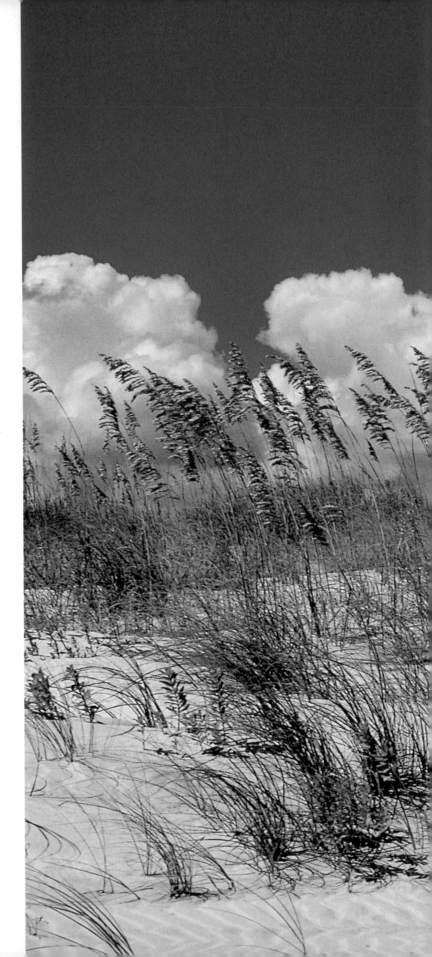

Contents

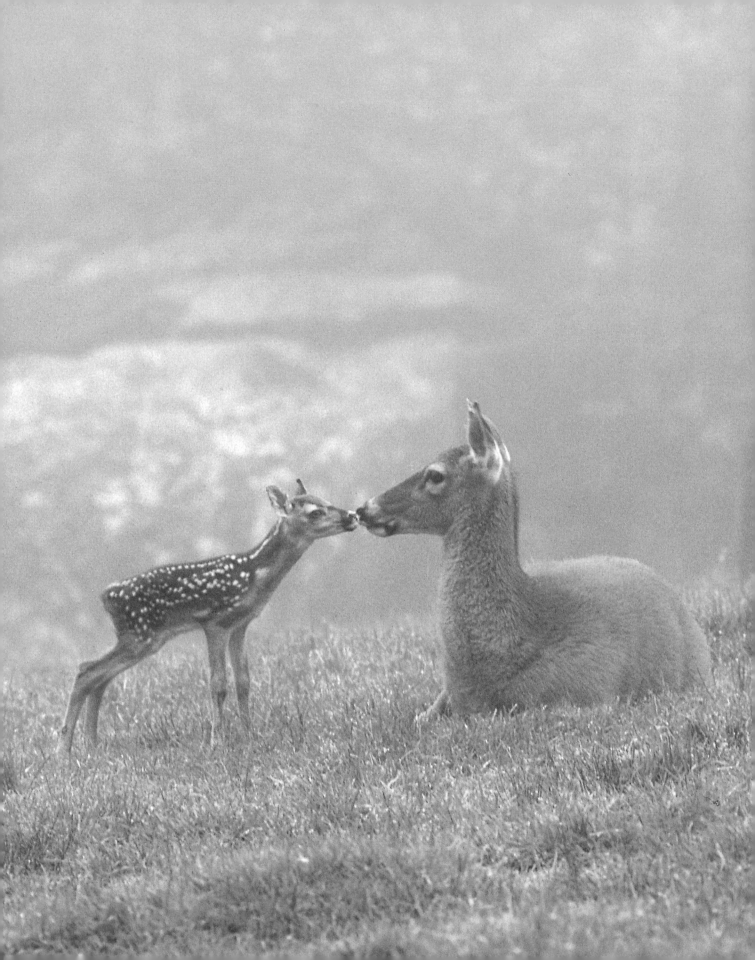

Foreword

In Planning *Hugh Morton's North Carolina*, David Perry, the University of North Carolina Press's editor-in-chief, and I examined the wealth of material in Hugh Morton's library of photographs of North Carolina, and one thing became immediately clear. One book would not suffice. Too many great pictures, too many great stories would have to be left out. So here is a second volume of Hugh Morton, and we hope you will be as pleased with it as we are.

Hugh Morton's lifelong love of nature and celebration of its bounty is revealed on the pages that follow. The brilliance of spring and fall flowers and the stark, harsh beauty of winter snow and ice are here. So, too, are the rivers, streams, forests, and beaches we all enjoy. Just think, all of this wonder and beauty is in our state.

Hugh loved birds and animals, especially bear cubs and their mischievousness. You will see squirrel, deer, mountain lion, opossum, and the majestic American eagle. He made each of us a companion in his personal discovery and enjoyment of the great natural endowment of which we are trustees.

By the way, friends, yet another treat is in store as Hugh found some more photos like those in volume 1. They are historic, and you will surely enjoy the memories they will awaken.

For Hugh and myself, I wish to express our personal gratitude and deep appreciation to the William R. Kenan Jr. Charitable Trust for generous grants that provide copies of both volumes of Hugh's work for each public school library and for each public library in North Carolina. The trust, through its members Mrs. James L. Wiley; Thomas S. Kenan III; JPMorgan Chase Bank, represented by Mary C. Dickens and Robert Baynard; Executive Director Richard M. Krasno; and Program Officer Zona Norwood, has been a strong supporter of the teaching of our history and of all important efforts dedicated to the education of our youth.

Finally, this personal note: As June 1, 2006, headed toward sunset on Grandfather, a gentle breeze was blowing. Peace was about, and Hugh slipped away from all of us. His life defined the term "public service." His good works were many, and the great joy of his life, after his family, was his camera and those thousands of moments he captured that help us all define ourselves and our great state and nation. He was a true patriot, and all North Carolinians have lost a great friend. I express our profound gratitude to Julia, his loving wife for over sixty years. Together they enriched the lives of us all.

William Friday

Preface

My family assured that my knowledge and love of North Carolina, from one end of the state to another, began early. I was born in Wilmington in February 1921, and by the time I was just four months old, I was spending the summer at Linville, where my father was helping develop the mountain resort that my grandfather had founded in 1885. As a youngster I learned enough about photography to work on student publications in high school and college. I also did freelance sports photographs for several North Carolina newspapers during college. In 1942 I enlisted in the U.S. Army and was a combat newsreel photographer in the Pacific in World War II.

A handful of the leading North Carolina journalists and public relations specialists, including Bill Sharpe, Charlie Parker, Lynn Nisbet, John Harden, Carl Goerch, Orville Campbell, and photographer Johnny Hemmer, took me under their wings after World War II. I became deeply involved in taking pictures to promote the state while serving for ten years as a member of the N.C. Board of Conservation and Development under Governors W. Kerr Scott, William B. Umstead, and Luther H. Hodges. I was chairman of the State Advertising Committee at the time Governor Hodges was leading the effort to form the Research Triangle.

The one thing that has led over the years to the most improvement of my photography has been the Southern Short Course in Press Photography. Fourteen of the first fifteen of those events were at the University of North Carolina. I benefited from the dozens of lectures and chaired the program those fourteen years. News photographer Joe Costa, who was known to photojournalism the same way Babe Ruth was known to baseball, threw his considerable weight behind the Southern Short Course at the request of Bill Sharpe and Johnny Hemmer. No person involved in American photojournalism could turn down an invitation extended by Costa, and our speakers were the best our nation could provide. Not just my camera work improved; the

skill of most of the serious news photographers in the region took a noticeable leap forward.

I would like to say a word about the man who has been my close collaborator in putting together this book and the earlier volume, *Hugh Morton's North Carolina*. In the thirty years he headed North Carolina's higher education system as president of the University of North Carolina, Dr. William Friday made thousands of friends. Julia and I are grateful to be two among them. Since retiring in 1986, Bill Friday has remained active in the public affairs of our state and nation. He is blessed with consistent good judgment and absolute truthfulness. Whatever Bill suggests I do, I do. He is the person who convinced me that publishing books of my photographs was the right thing to do. He and I have had a lot of fun traveling around the state, giving talks, meeting citizens, and enjoying the warm reception the first book received. We hope this one will be a worthy successor.

This book is organized in two sections: "Scenes" and "People." In the "Scenes" section, the photographs are loosely organized in a west-to-east arrangement. Dates have been supplied when it seemed they were important to viewing the picture.

Scenes

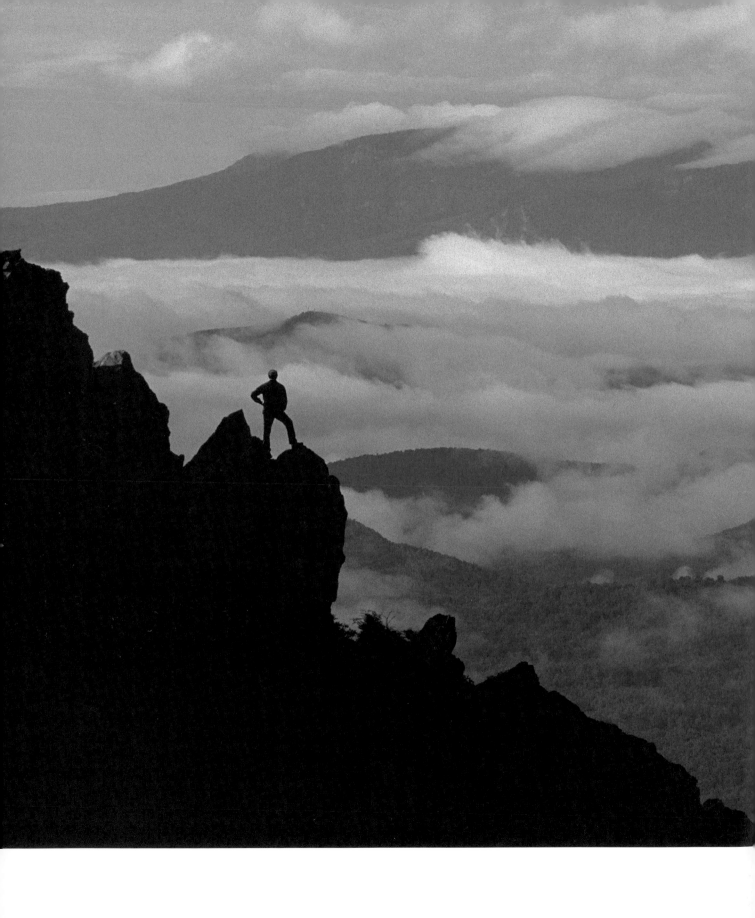

Hiker on Linville Peak of Grandfather Mountain. In the background are Mount Mitchell and the Black Mountain range.

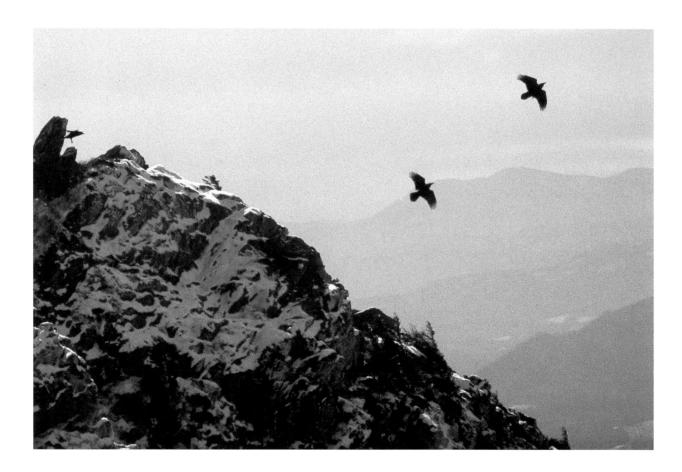

Ravens soaring on the ridge lift created
by winter wind hitting Linville Peak of
Grandfather Mountain.

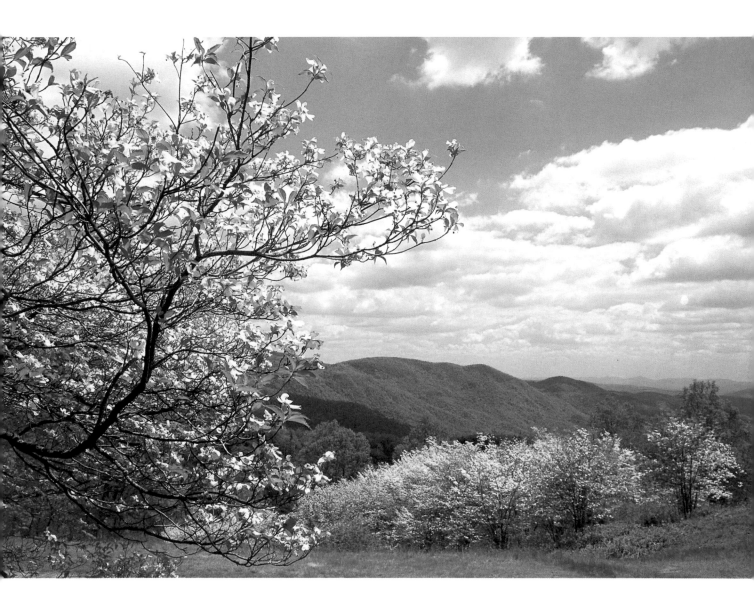

Dogwoods on the Blue Ridge Parkway
between Boone and Deep Gap.

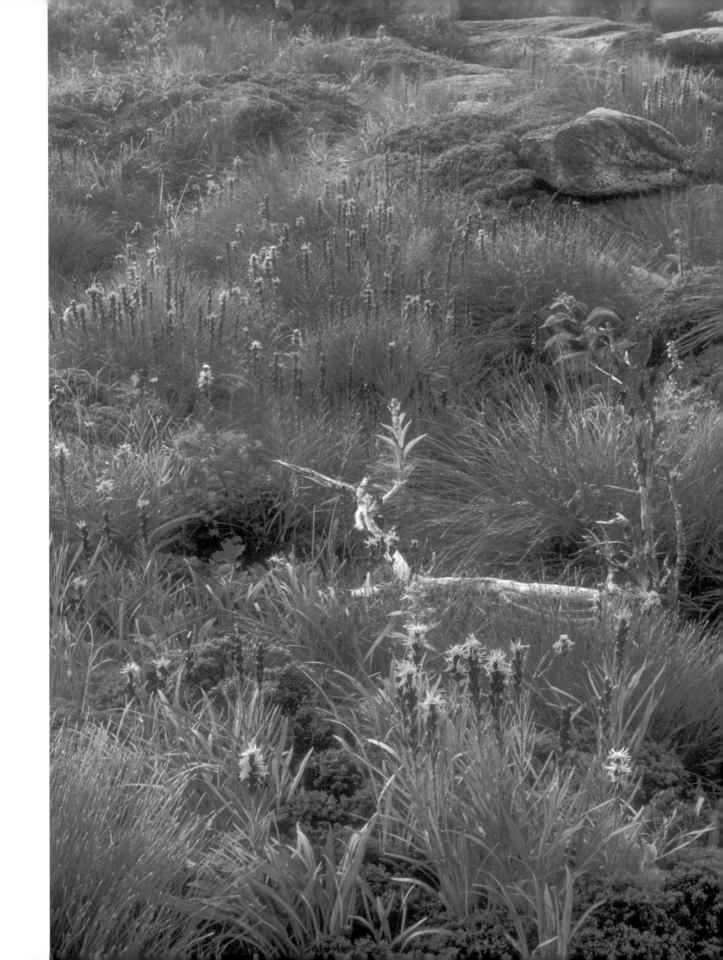

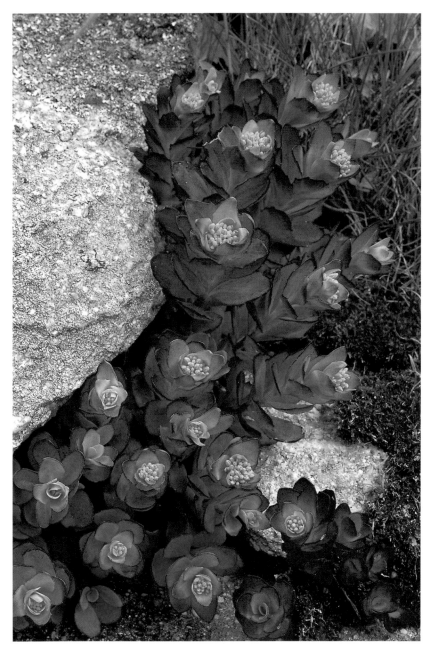

Sedum live-forever, one of the plants discovered by French botanist André Michaux more than 200 years ago.

opposite:
Heller's blazing star, a rare and endangered species. It blooms on high rocky peaks in August.

overleaf:
Black bear cub. This one, a "brown-phase" bear, was named Cocoa by the managers of Grandfather Mountain's cub habitat.

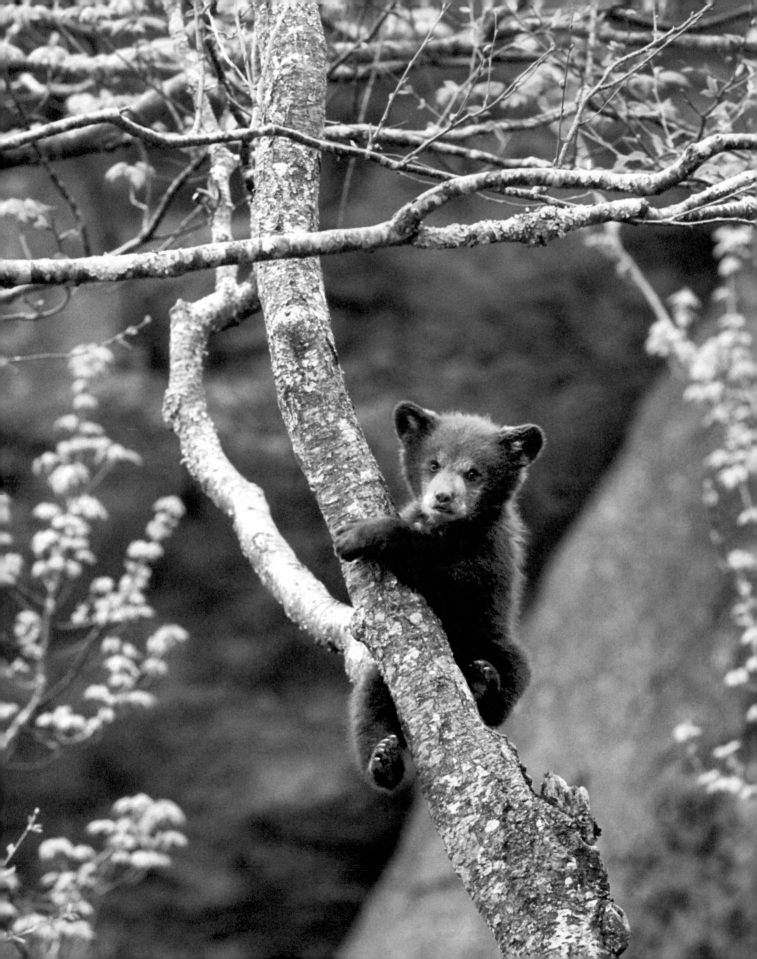

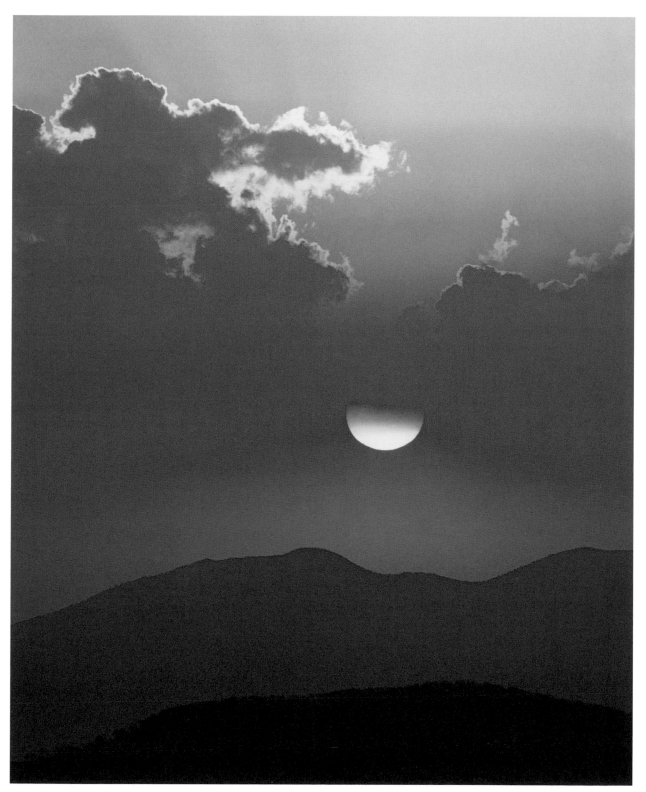

Mountain sunset.

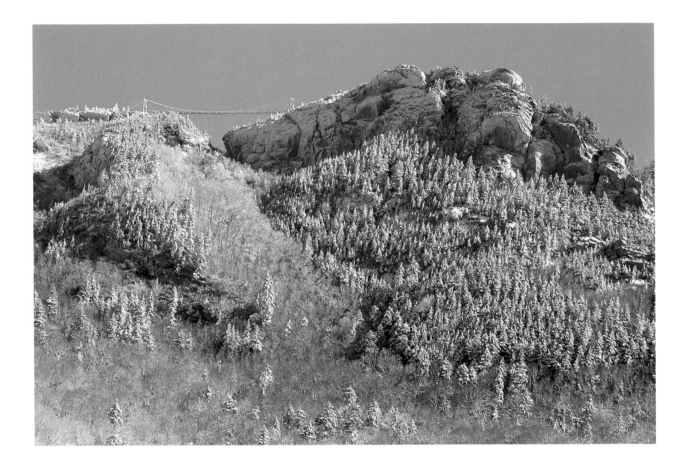

The Mile High Swinging Bridge on the
crest of Grandfather Mountain, frosted
with rime ice.

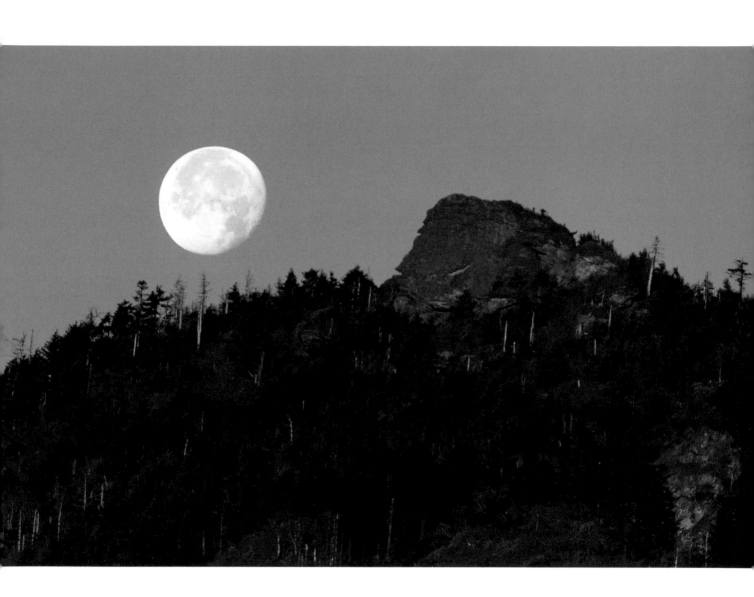

A full moon setting over a
mountain illuminated by the
first rays of a rising sun.

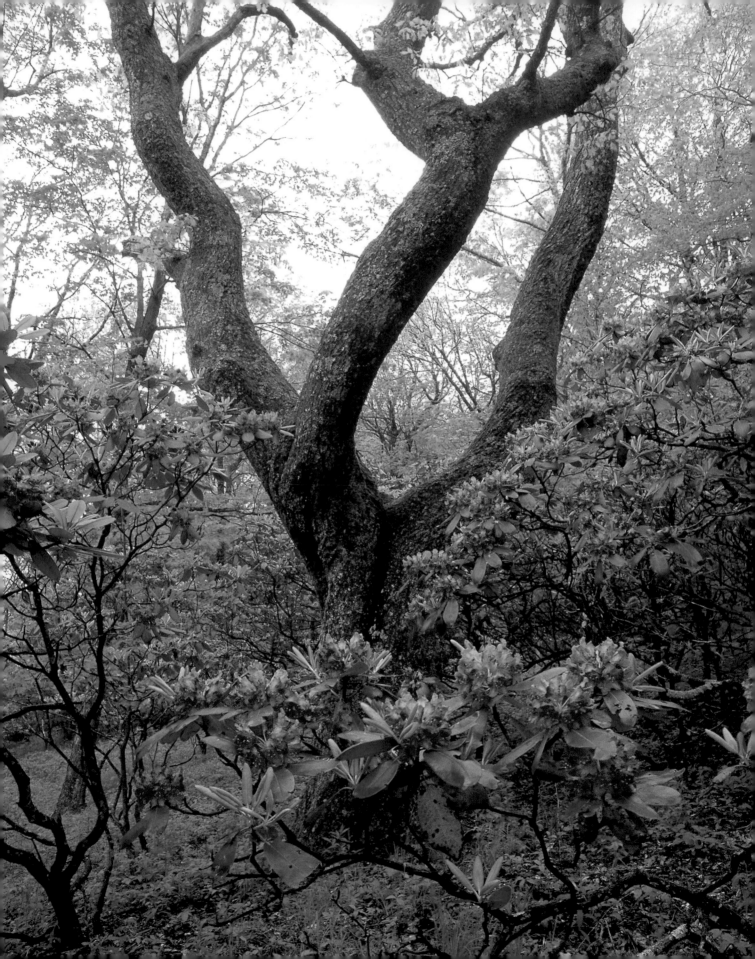

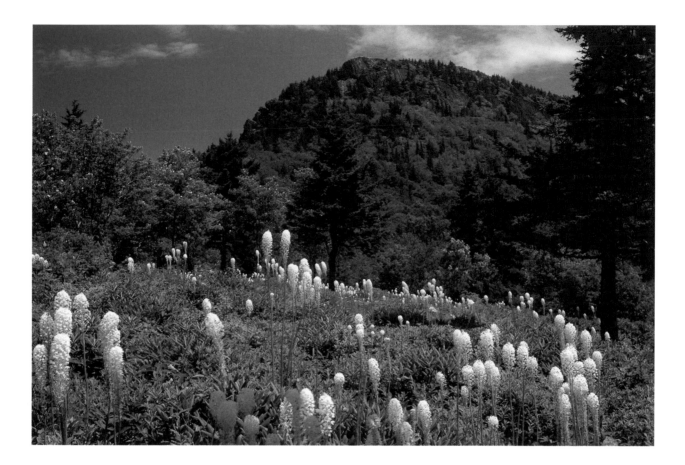

opposite:
Catawba rhododendron. At lower elevations it blooms as early as May 15; at higher elevations it can bloom as late as the latter part of June.

Turkey beard. Its blossoms are popular snack food for deer, making the plant somewhat rarely seen.

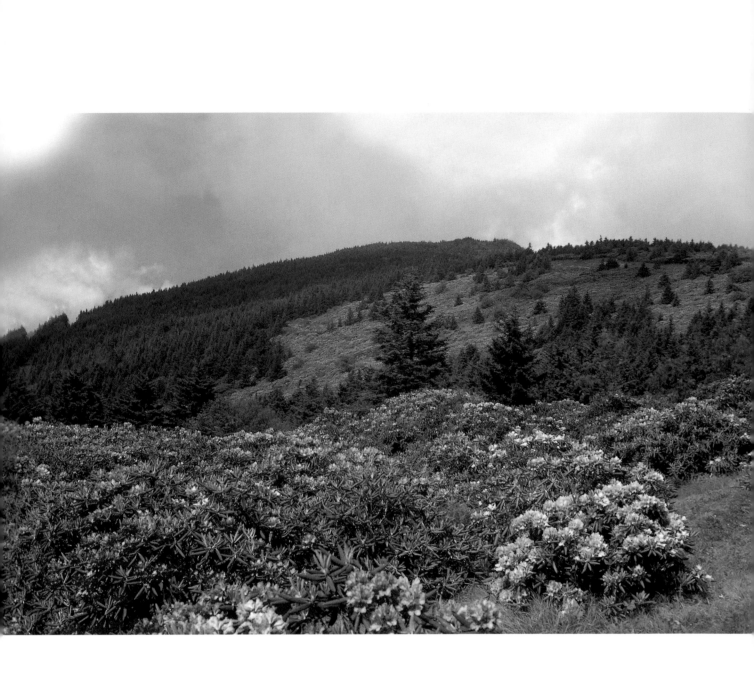

Roan Mountain, the largest natural
rhododendron garden in the world.
It covers 800 acres on the North
Carolina–Tennessee border.

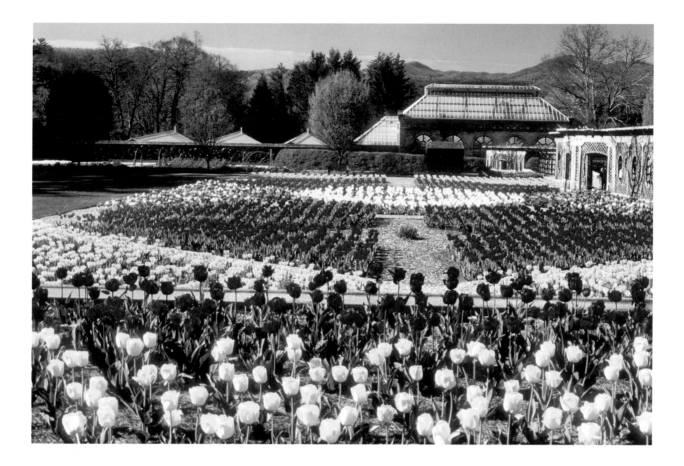

Blooming tulips in the walled garden at Biltmore Estate in Asheville. The building is the conservatory, a display greenhouse that includes elaborate rooms for orchids and cactus.

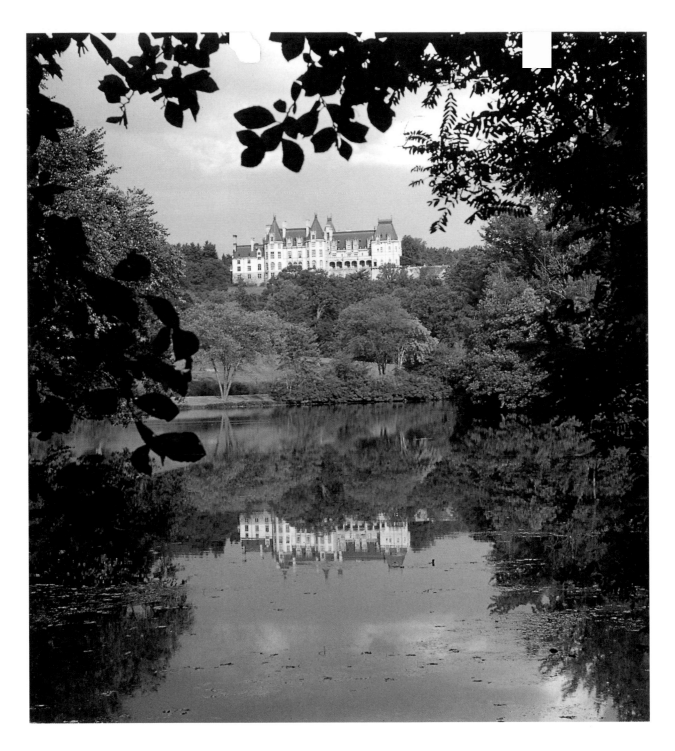

The magnificent Biltmore mansion
in Asheville, reflected in the small lake
known as the lagoon.

opposite:
Davidson River, near Brevard and
U.S. 276 through the Pisgah National
Forest.

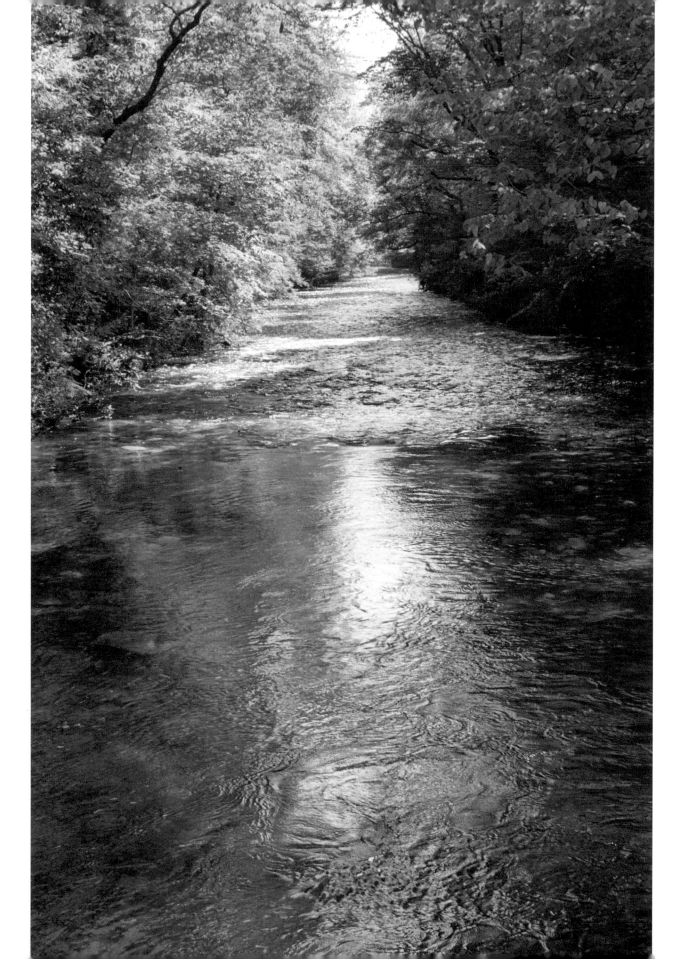

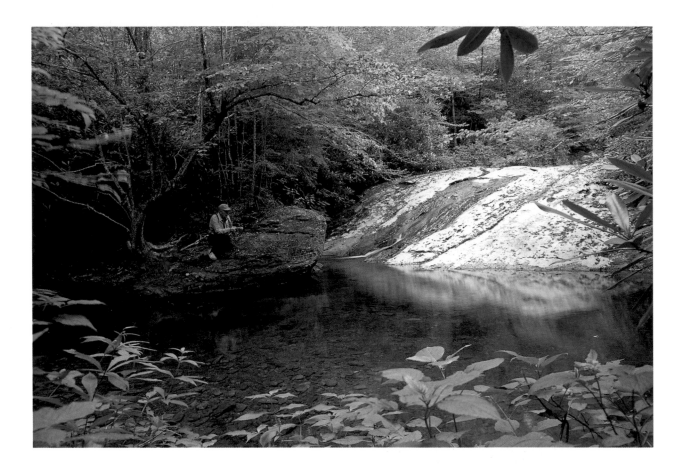

Luther H. Hodges, former governor
of North Carolina and secretary of
commerce in the cabinets of John F.
Kennedy and Lyndon B. Johnson,
fishing on Grassy Creek, a tributary
of the Linville River.

opposite:
Looking Glass Falls,
in Pisgah National Forest,
near Brevard.

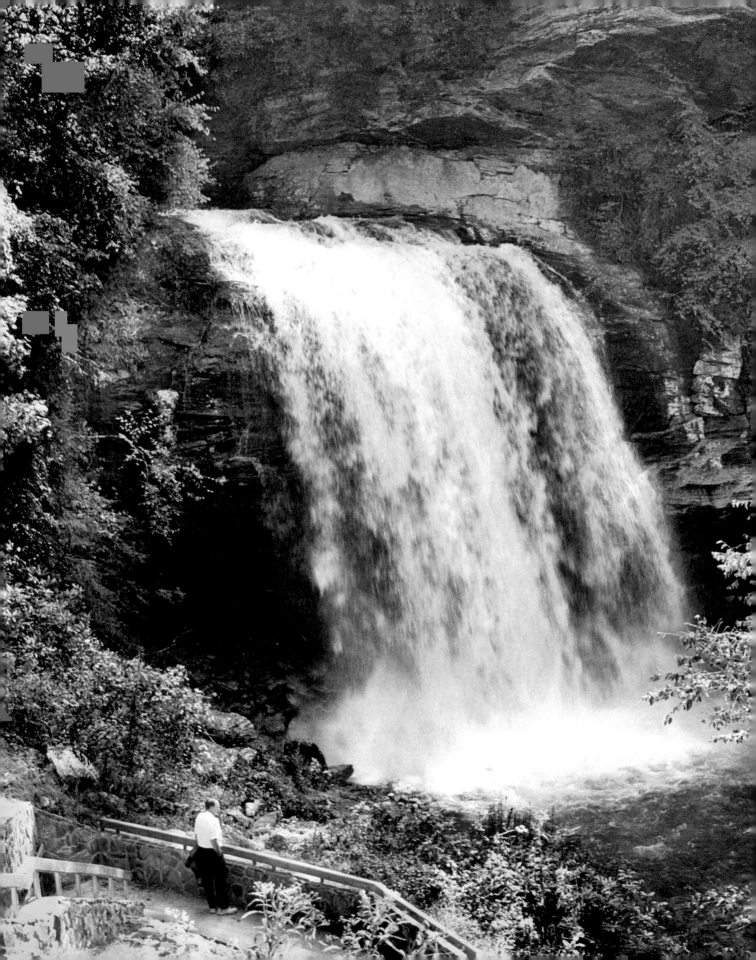

Shortia. Noted French botanist
André Michaux discovered this
plant in 1788.

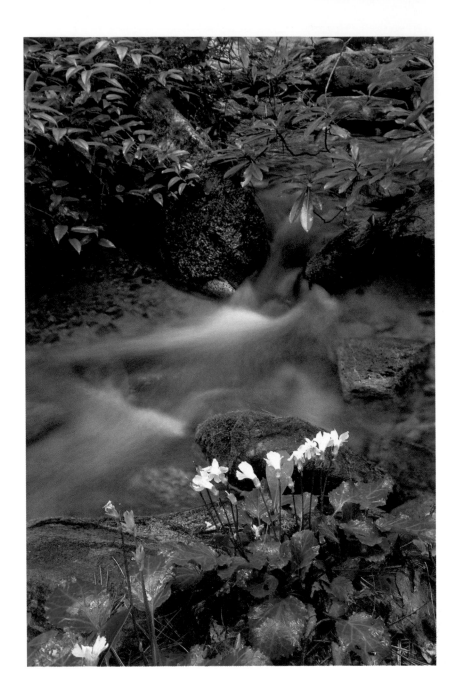

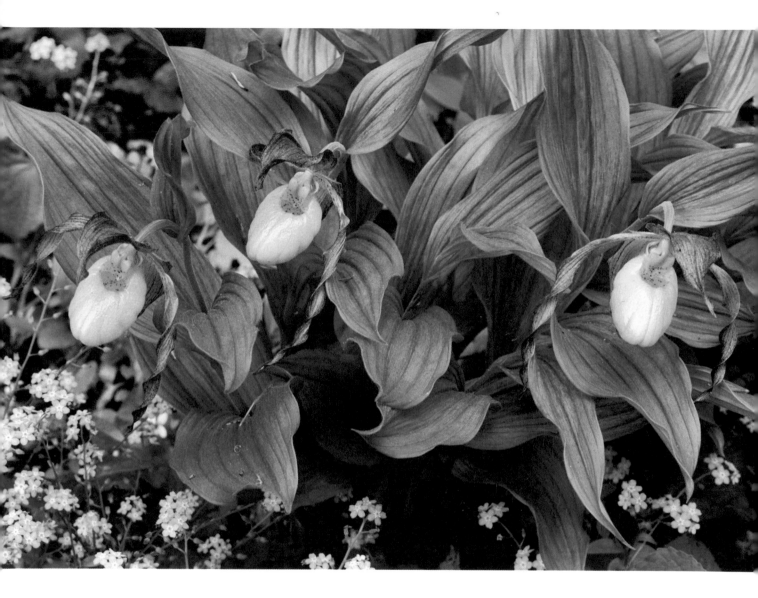

Yellow lady slippers and
forget-me-nots.

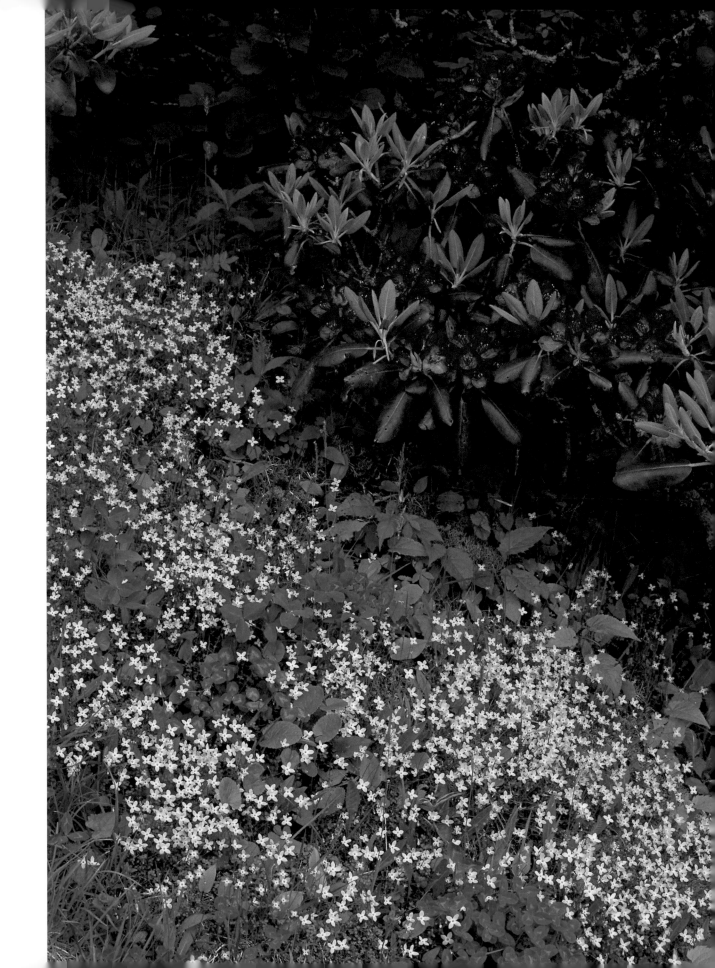

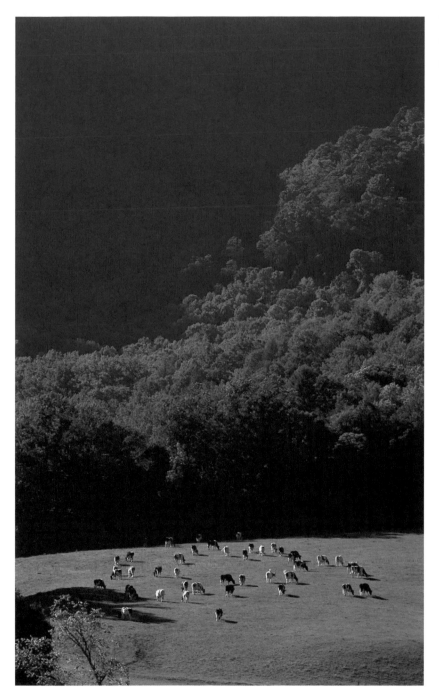

The English family dairy farm, at the foot of Linville Mountain south of Linville Caverns in McDowell County.

opposite:
Purple-red Catawba rhododendron and tiny bluets.

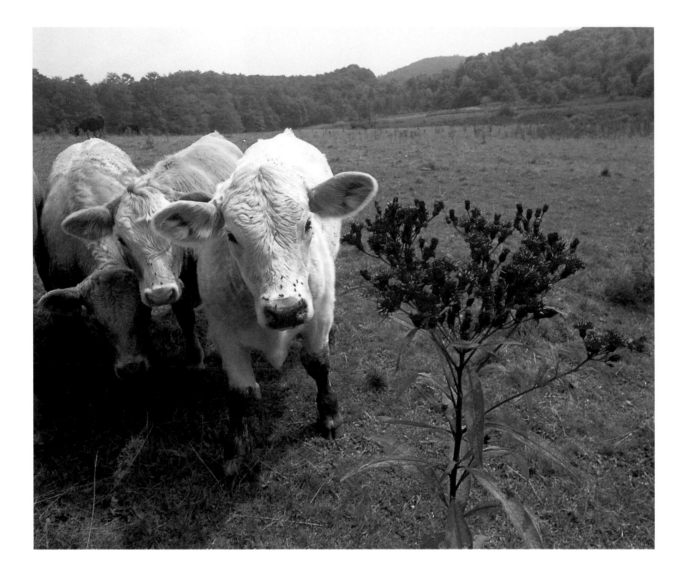

Cows in a field of ironweed on
the Blue Ridge Parkway at Julian
Price Park.

24

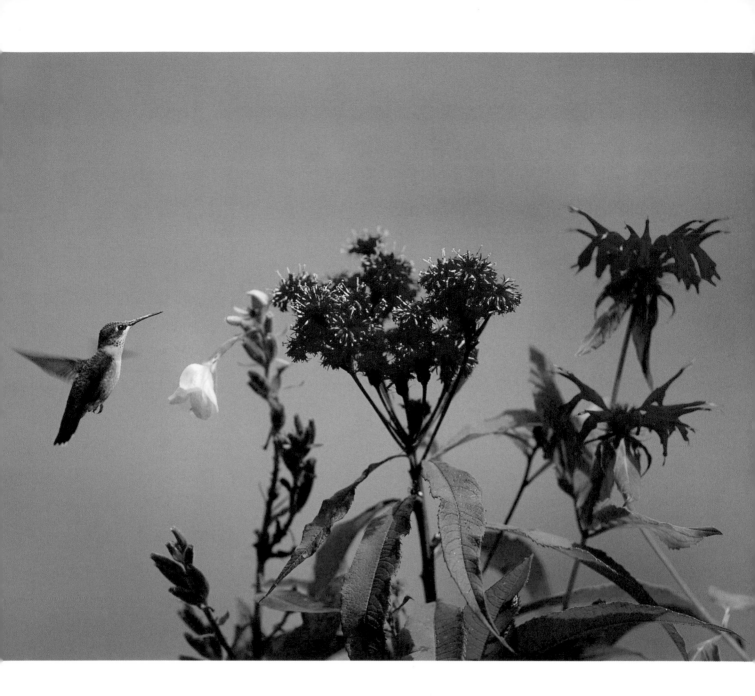

A female ruby-throated hummingbird
feeding on yellow evening primrose,
purple ironweed, and red Oswego tea.

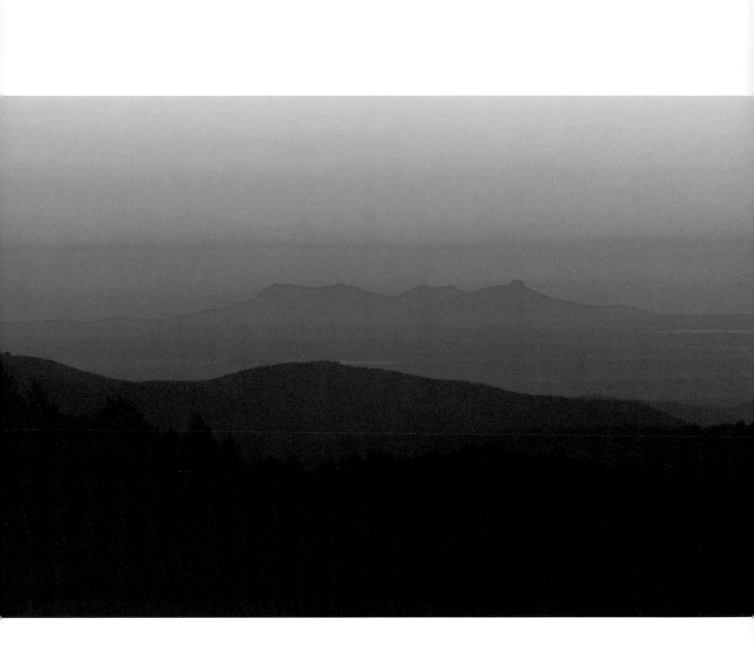

Pilot Mountain, between Mount
Airy and Winston-Salem, as seen
from Grandfather Mountain, some
eighty-seven air miles away.

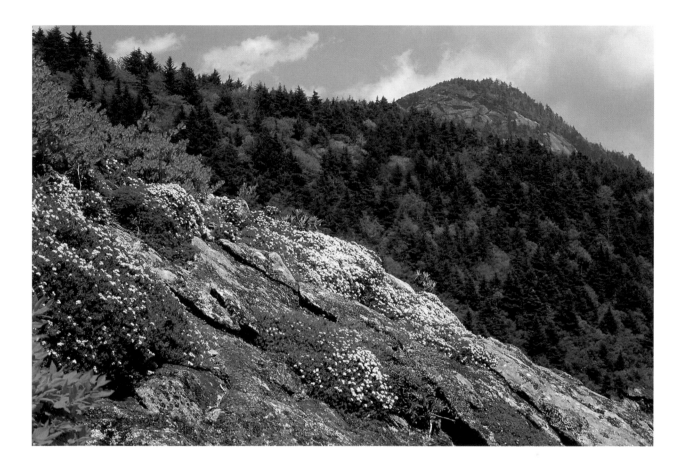

Alleghany sand myrtle, a dwarflike shrub that clings to high-elevation rock formations in the North Carolina mountains, where it appears to need almost no soil to sustain it. The plant does not thrive when attempts are made to transplant it to richer soils at lower elevations.

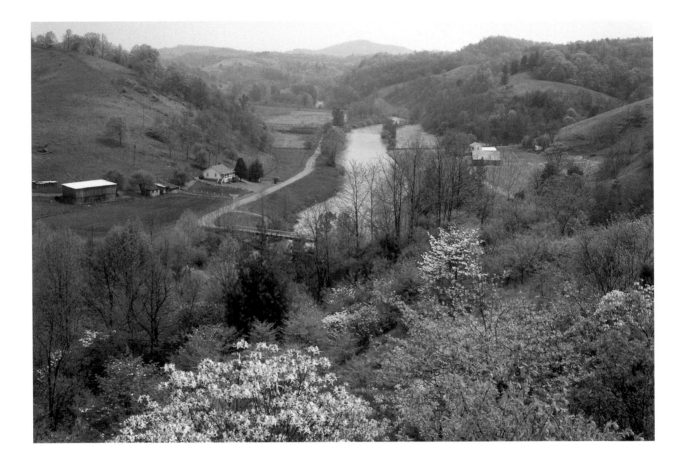

The New River, one of the oldest
rivers in North America, meanders
through scenic farms and woodlands
of Ashe and Alleghany Counties.

opposite:
Farm near Deep Gap, near
the Wilkes-Watauga county line,
in October.

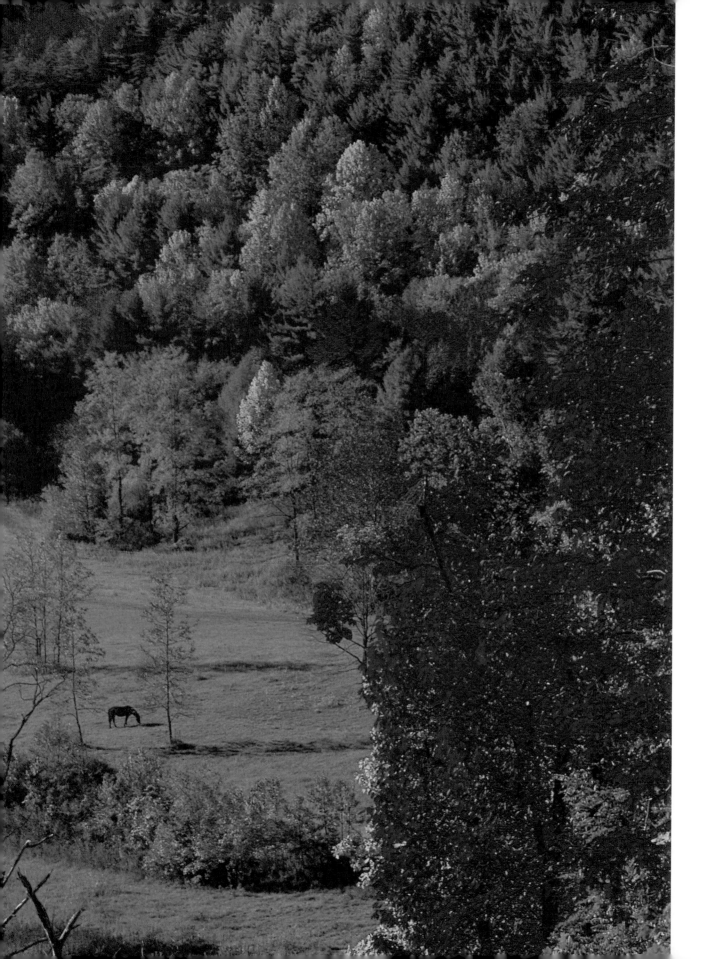

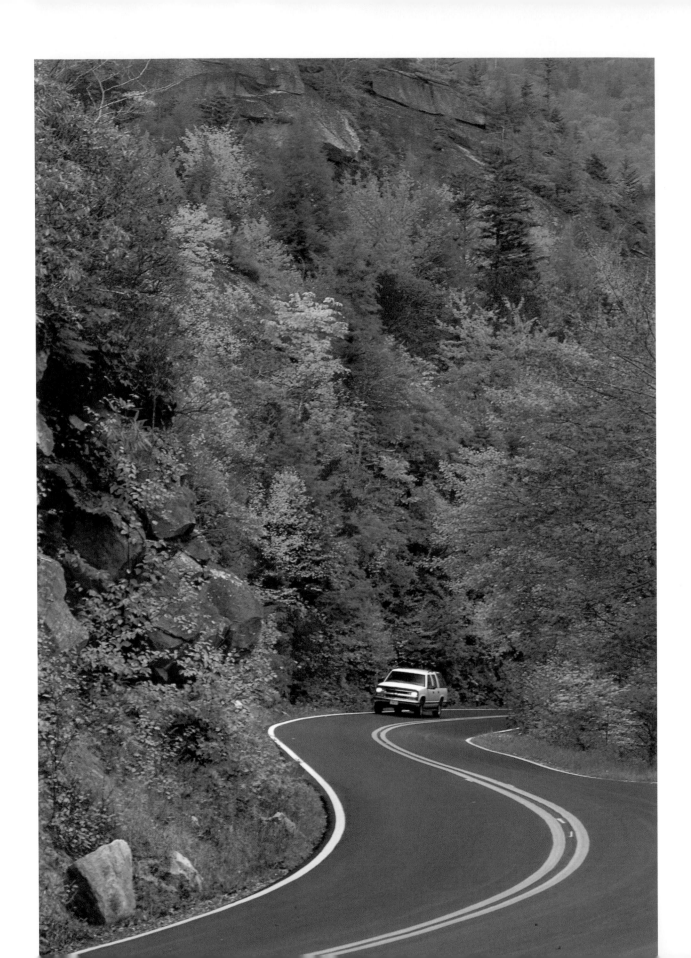

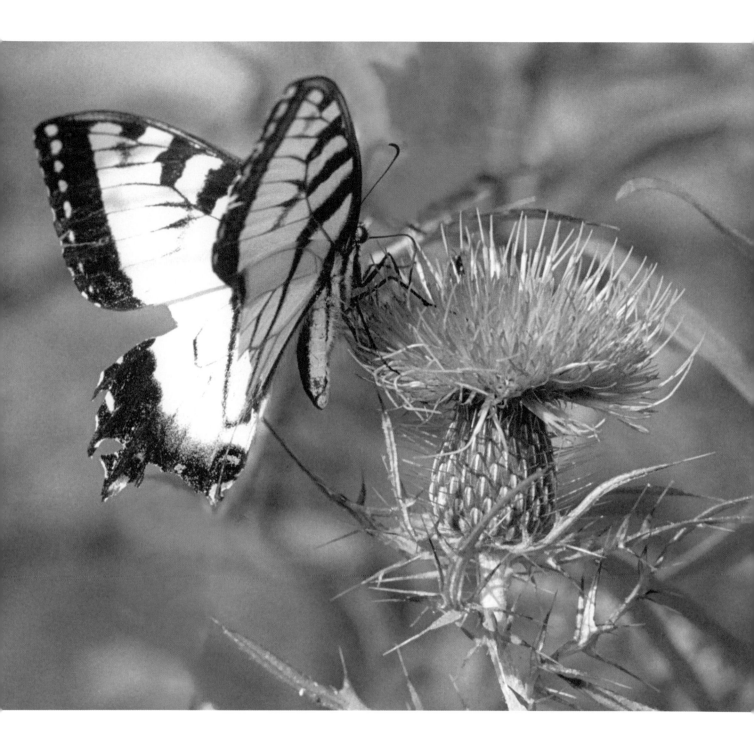

opposite:
Fall color on U.S. 221 between
Blowing Rock and Linville.

Male tiger swallowtail, common in all
parts of North Carolina, feeding on the
blossom of the thistle.

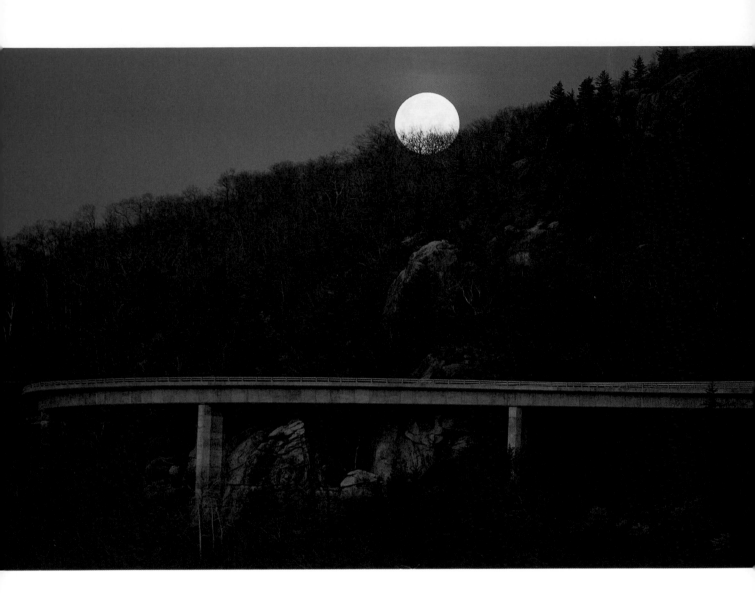

Moon setting over the viaduct,
one of the engineering marvels
of the eastern United States.

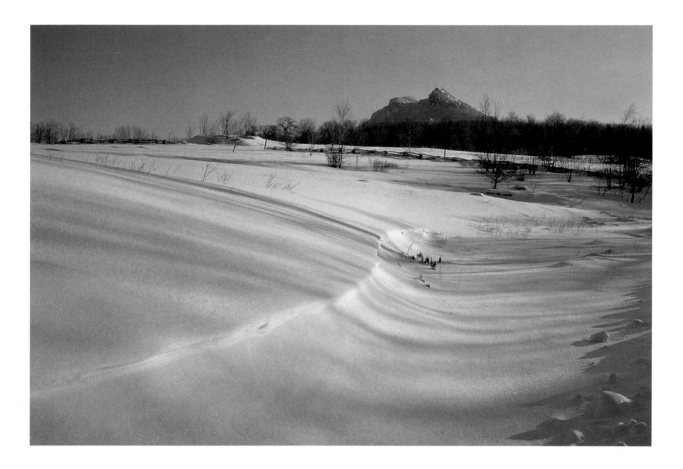

Snowdrifts at MacRae Meadows,
Grandfather Mountain.

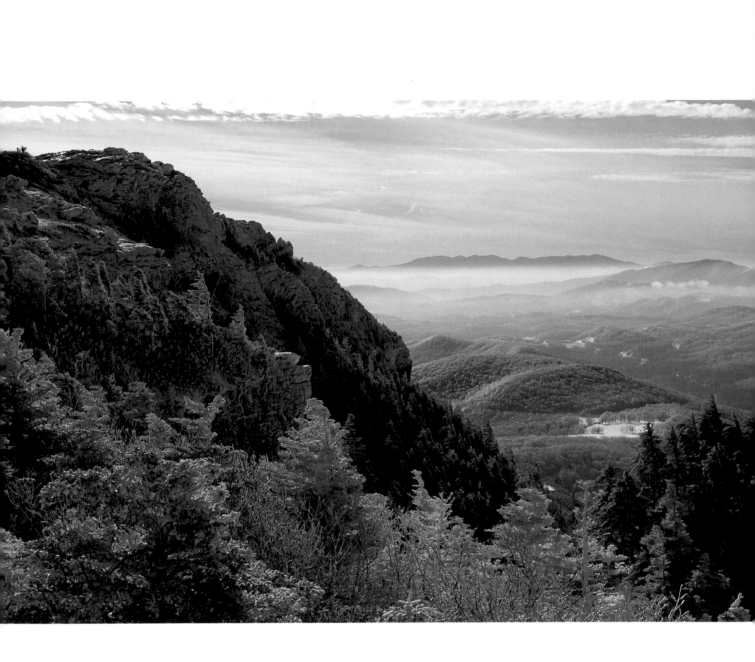

Linville Peak of Grandfather
Mountain. In the distance above
the clouds is the Black Mountain
range, which includes Mount Mitchell
(elevation 6,684 feet), highest point
in eastern North America.

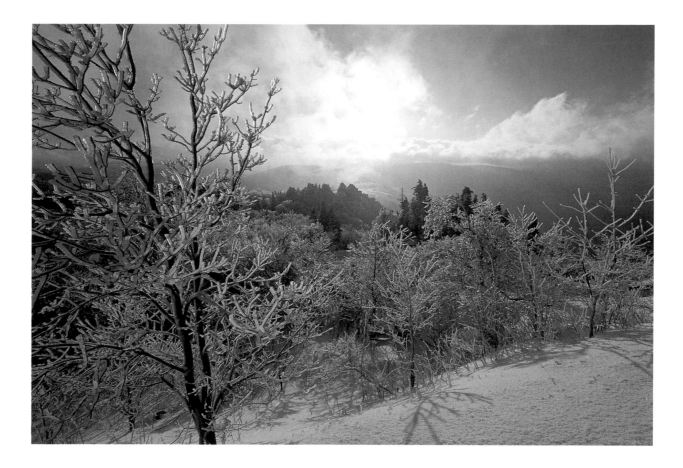

Winter scene in the Blue Ridge.

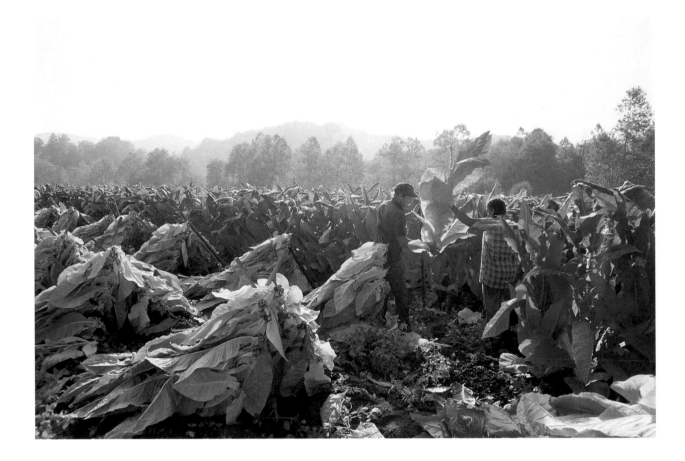

Harvesting burley tobacco
in the mountains.

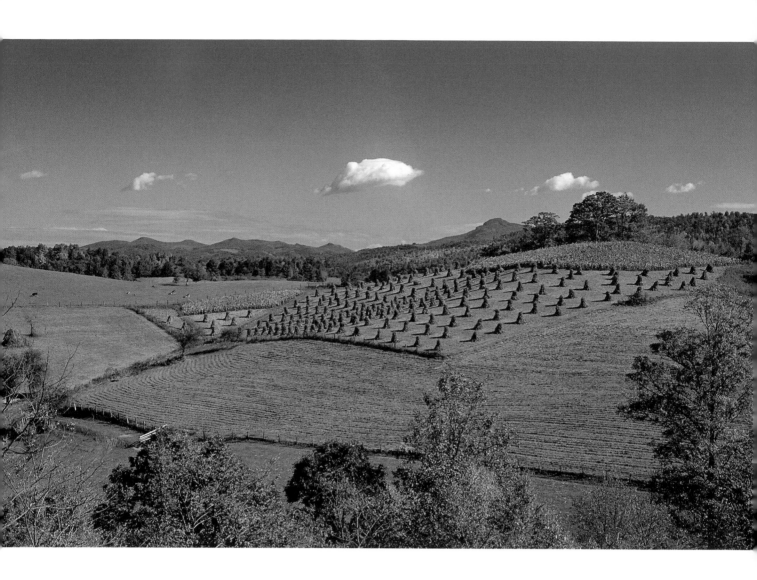

Corn harvested by hand and stacked in individual shocks at Altamont in Avery County. Today most cornfields are harvested by mechanical corn pickers. This may be more efficient, but modern corn harvests are not nearly as picturesque.

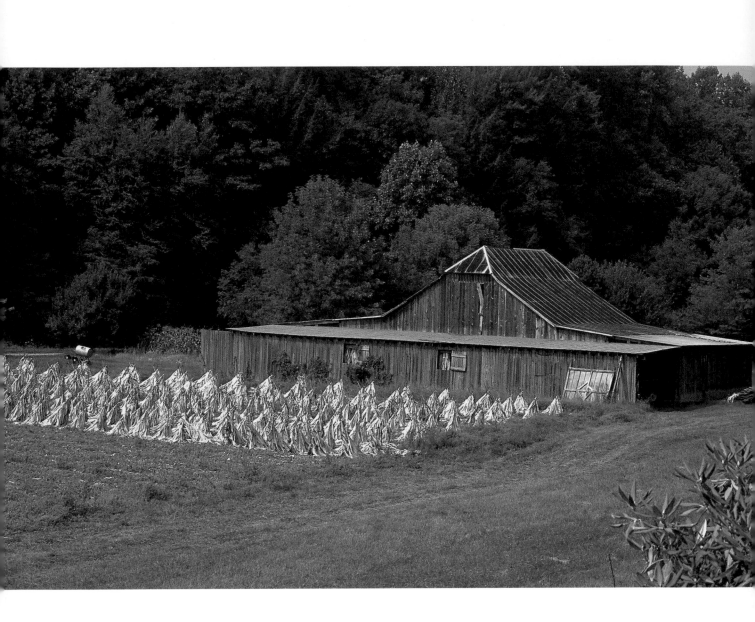

Burley tobacco plants staked to dry
in the field.

Mountain cabin near Foscoe in
Watauga County, 1940s.

Jesse Brown's cabin, a restored
pioneer-era log home on the Blue
Ridge Parkway, near Deep Gap.

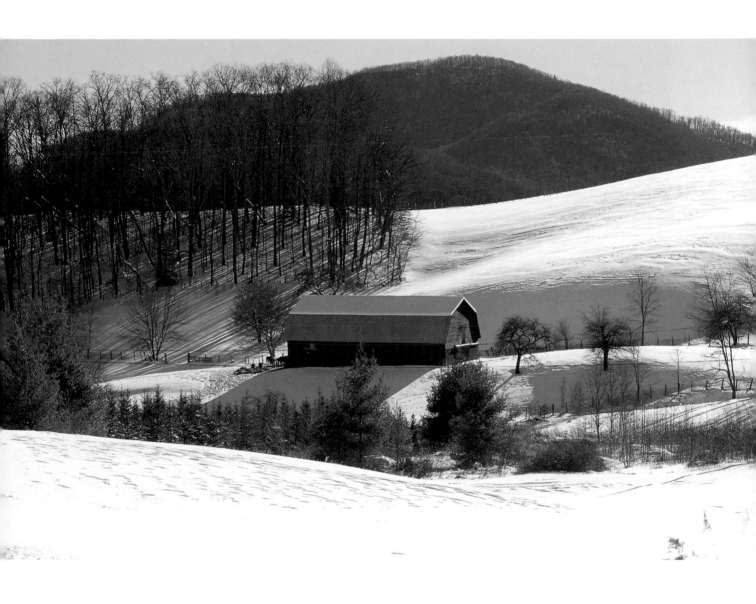

Farm scene near Linville Falls.

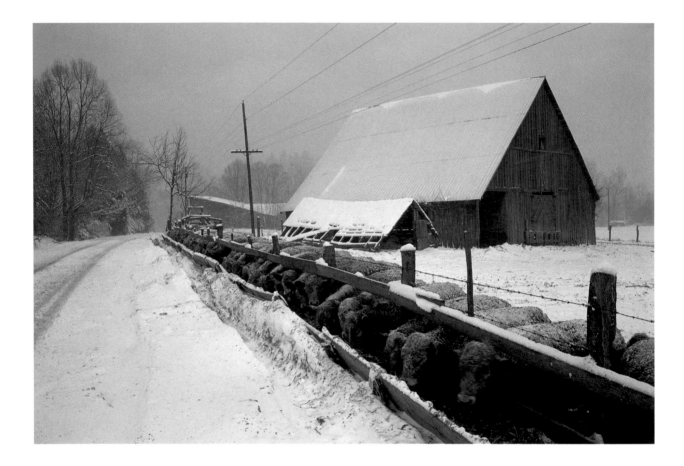

Cows feeding near Boone.

This mountain cabin near Crossnore is more than a century old. Once a residence, it now shelters a couple of sturdy horses.

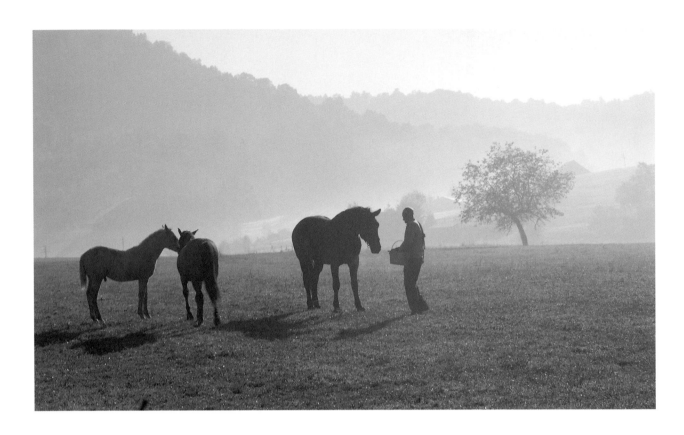

Farmer and his horses,
near Spruce Pine.

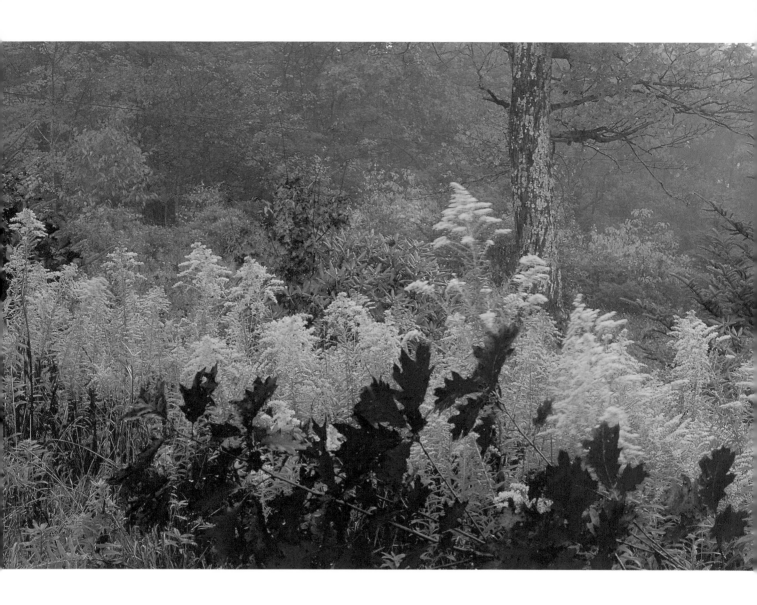

Fall scene. The bright red leaves
are oak, the yellow is goldenrod, and
the orange leaves in the middle are
sassafras.

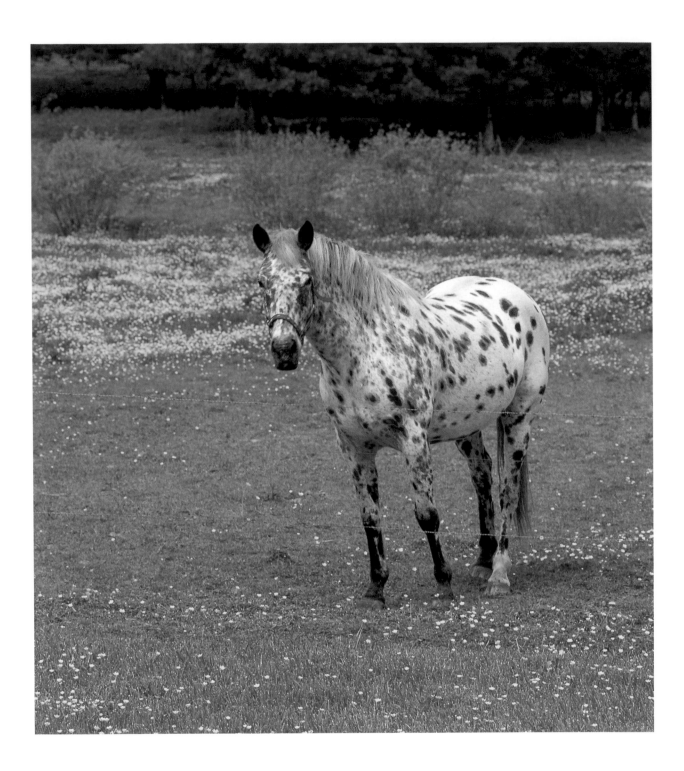

Leopard Appaloosa, Montezuma, N.C.

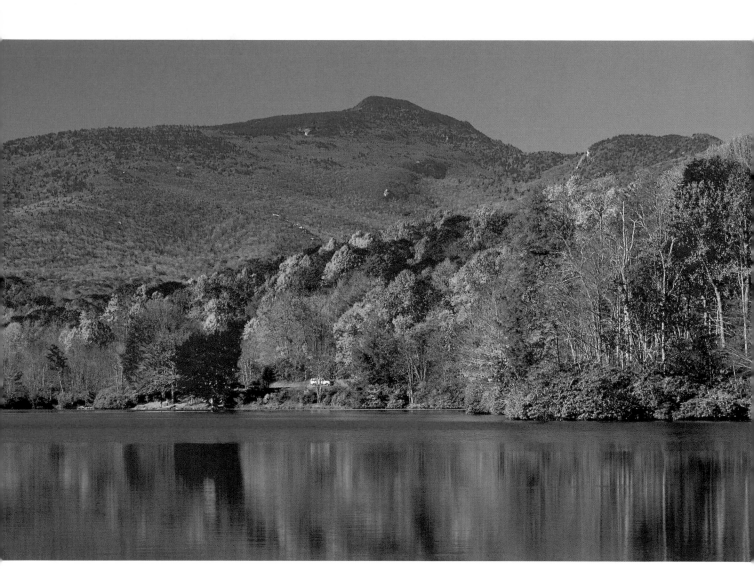

The lake at Julian Price Park
on the Blue Ridge Parkway near
Blowing Rock is dazzling in October.
Towering in the background is
Calloway Peak of Grandfather
Mountain (elevation 5,964 feet),
highest point on Grandfather and in
the Blue Ridge mountain range.

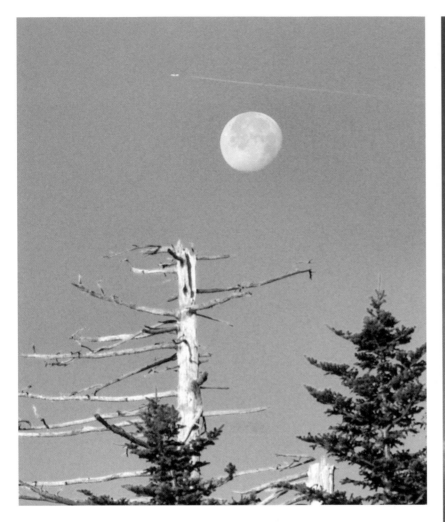

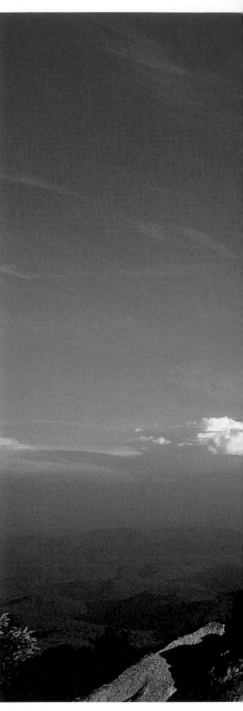

Moon setting above a dead spruce
at the top of Grandfather Mountain.
Little did we know until the film was
developed that a tiny airplane at
perhaps 30,000 feet would show up
in the sky above and to the left of
the moon.

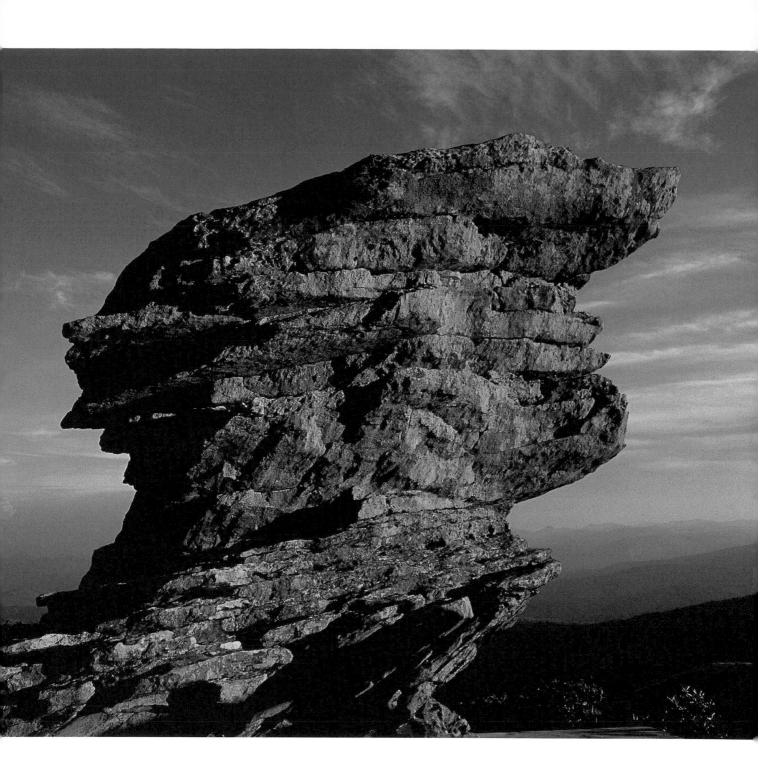

Rough Ridge Rock on the Blue Ridge Parkway's Tanawha hiking trail.
The flat and curved layers of metamorphic sandstone were deposited in
an ancient riverbed more than 650 million years ago.

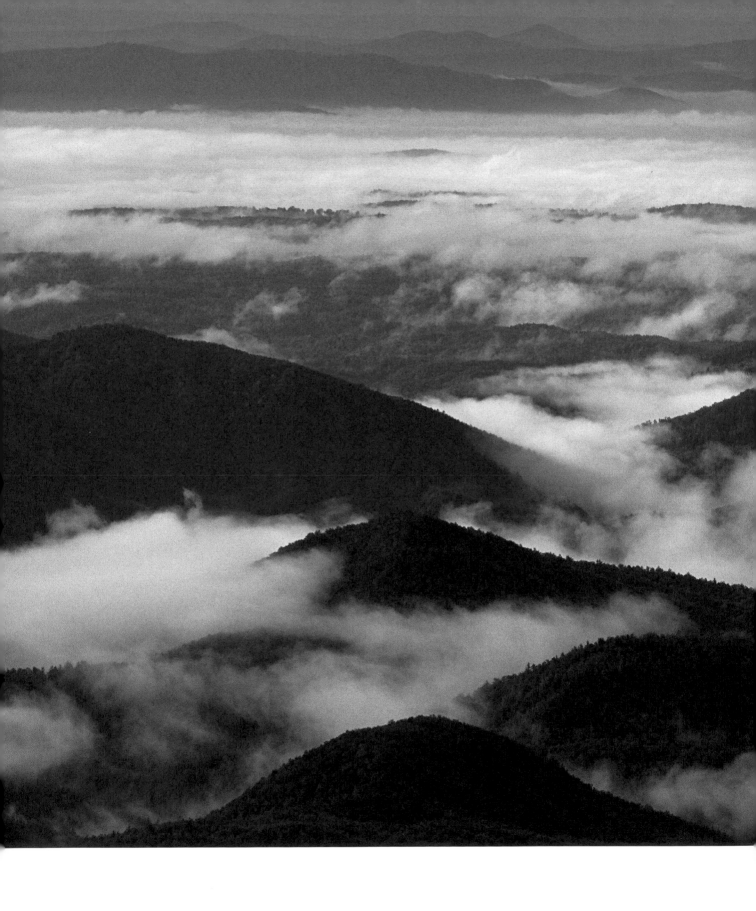

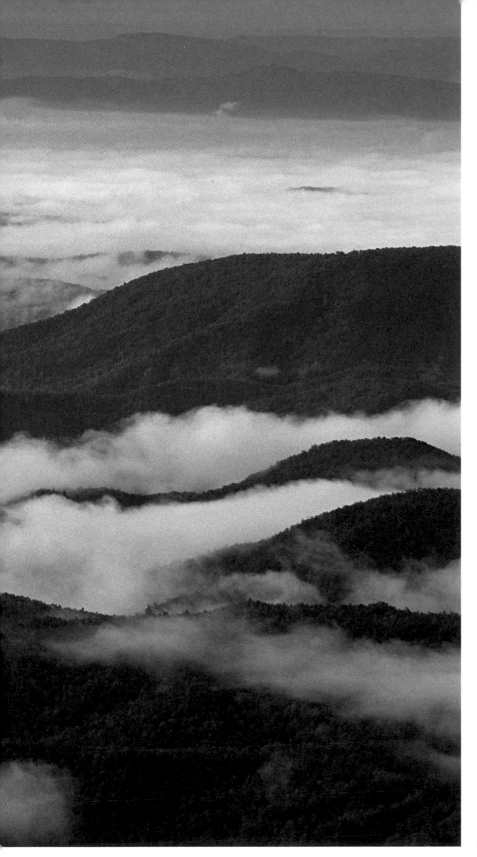

Mountains, just after a rainstorm.

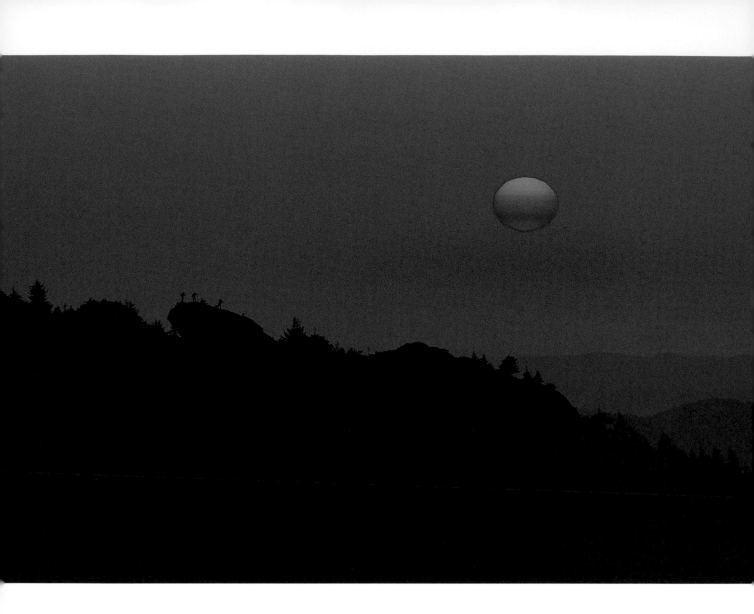

Hikers on Black Rock Cliffs, directly
above the Blue Ridge Parkway viaduct.

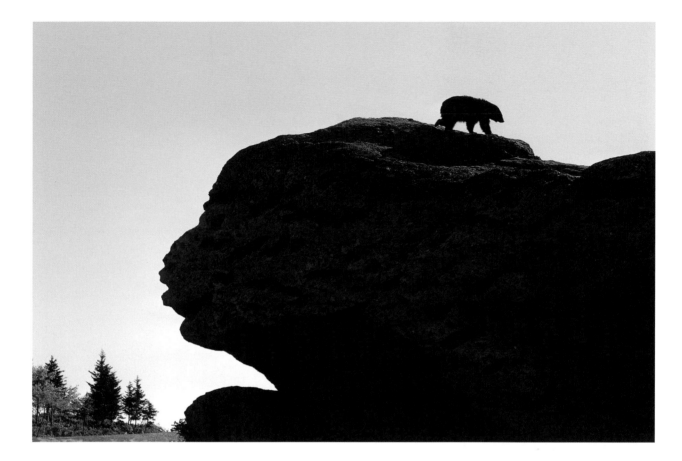

Mildred the bear, beloved mascot of
Grandfather Mountain, on top of the
Sphinx Rock, at Grandfather.

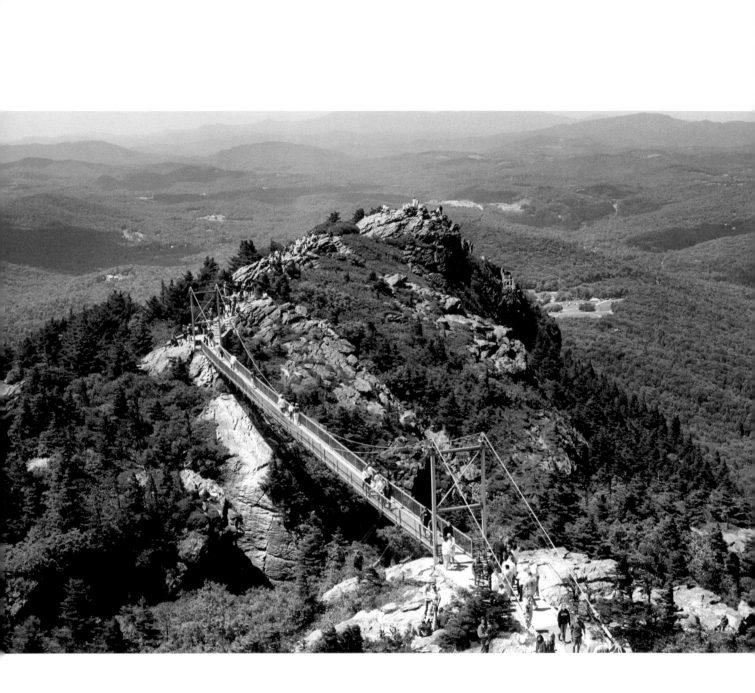

The Mile High Swinging Bridge on
Grandfather Mountain.

54

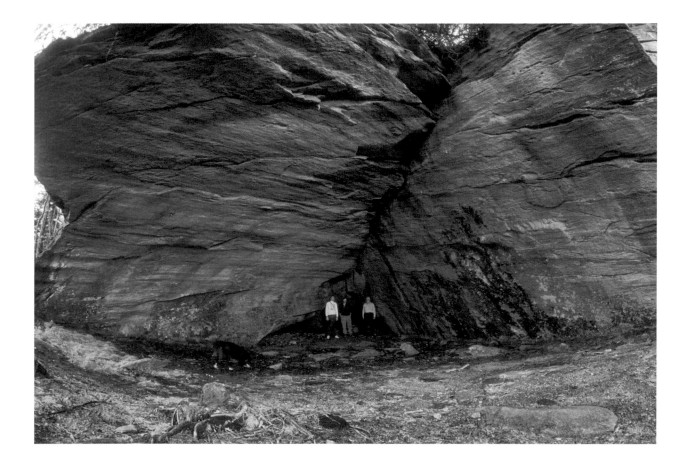

Indian House Cave on the
Attic Window Peak of Grandfather
Mountain, which was frequented
by Cherokees prior to the arrival
of pioneers.

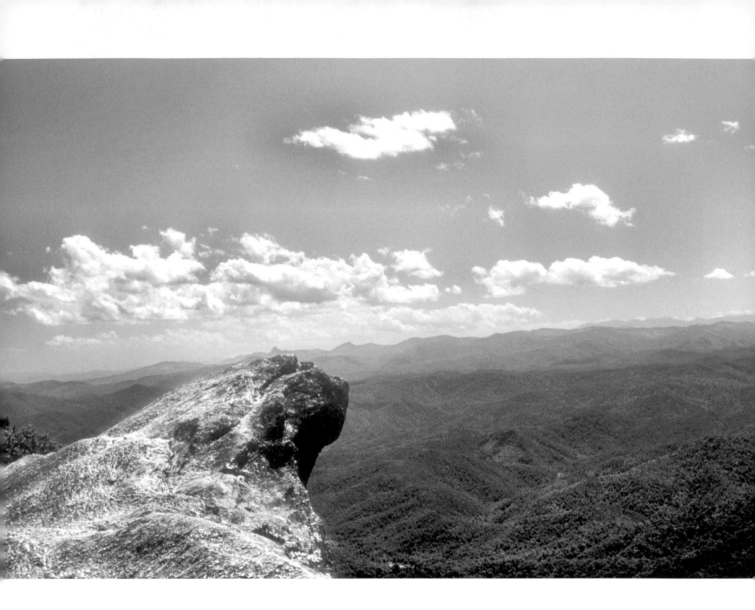

Blowing Rock, the attraction that gave
the thriving resort town its name.

opposite:
Since time began, humans have
wanted to fly with the birds, but no
one has done it better than John
McNeely, as this photograph attests.
John was both a pilot and a skilled
naturalist with the patience to train a
red-tailed hawk to fly with him while
he flew his hang glider.

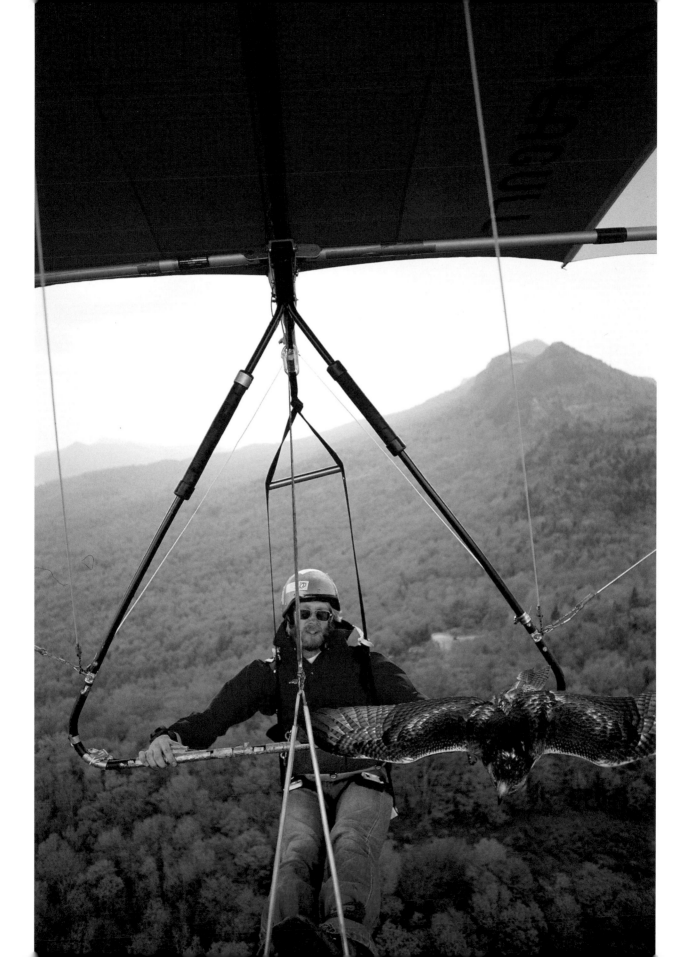

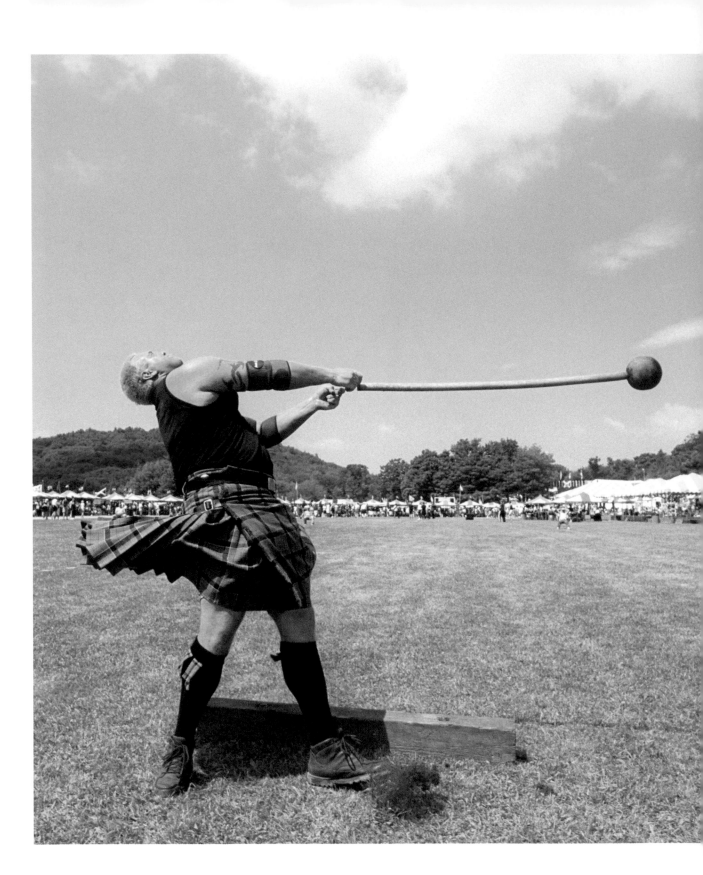

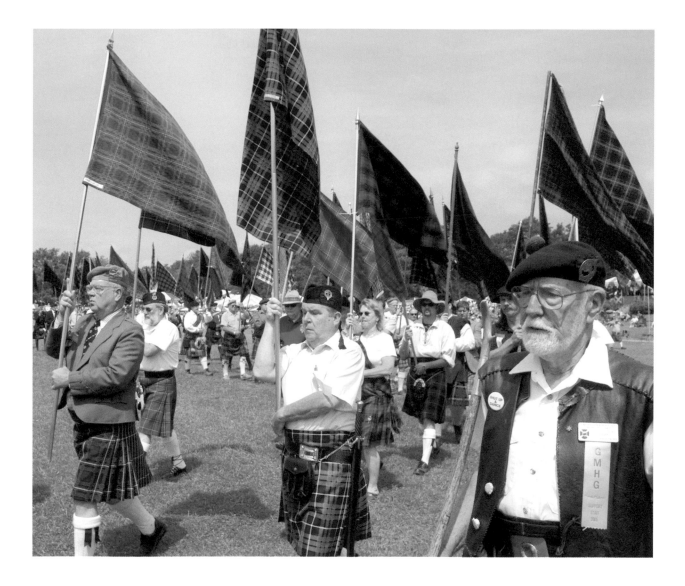

Larry Brock, former
Appalachian State football
lineman, the top Scottish
athlete at the 2004
Grandfather games.

The Parade of Tartans, the
most colorful part of the four-day
Grandfather Mountain Highland
Games and Gathering of Scottish
Clans.

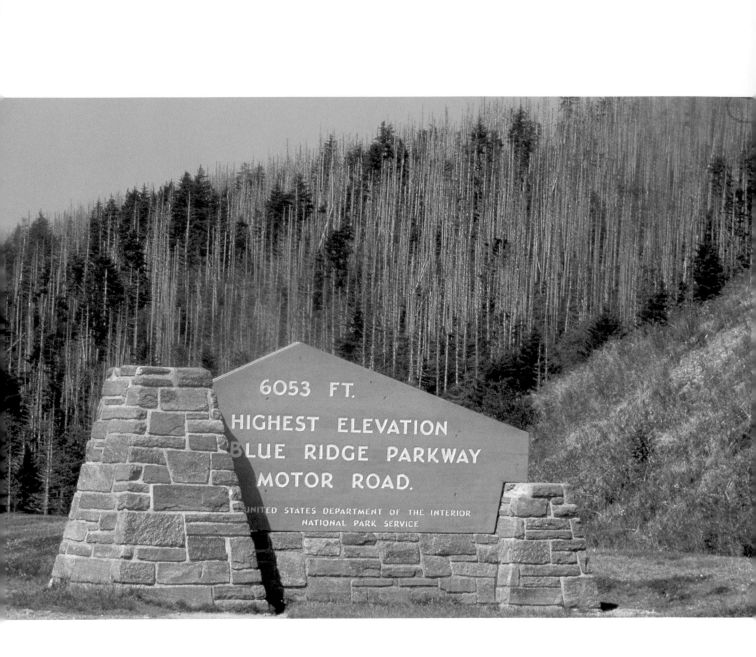

Richland Balsam (elevation 6,053 feet), the highest point on the Blue Ridge Parkway. Like other high peaks in the North Carolina mountains, the balsams are taking a beating from acid rain.

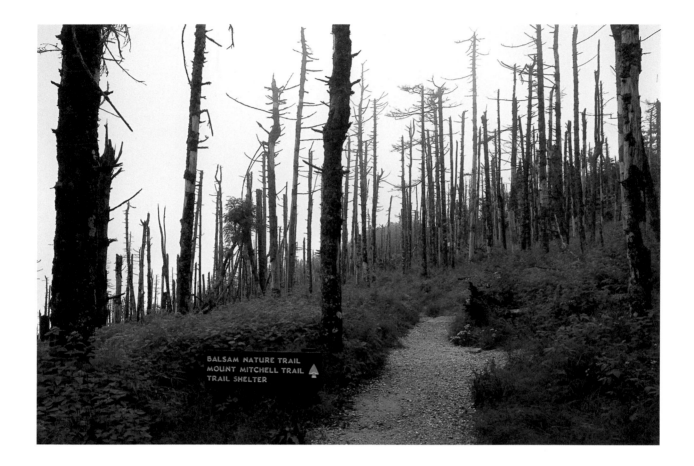

Balsam Nature Trail on top of Mount
Mitchell. Sadly, all the balsams have
been killed by acid rain.

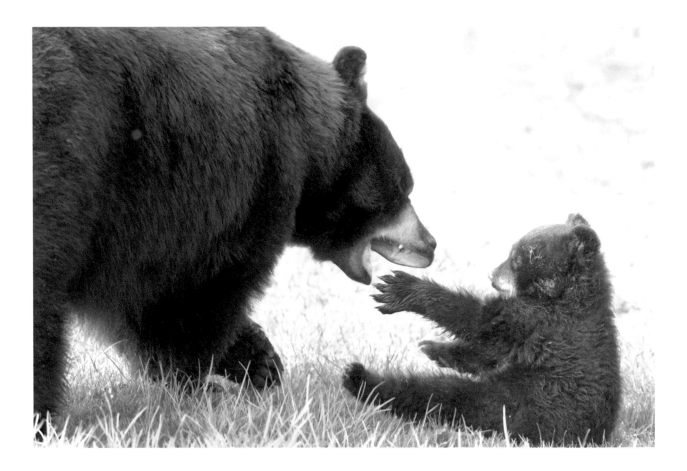

In most years there is more than
one cub in the Grandfather Mountain
habitat, and they play together all day
long. Boomer had only his mother to
frolic with, and Carolina was lovingly
tolerant of his playfulness.

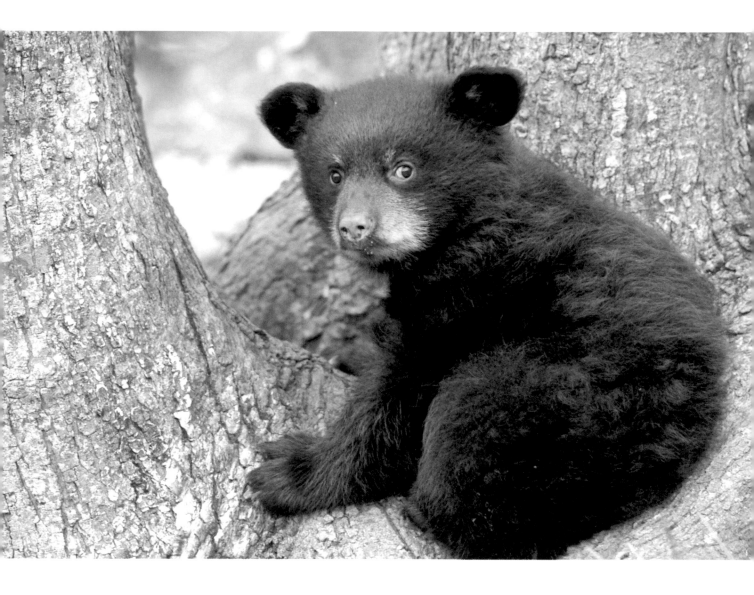

Boomer was born the last week
in January 2005, but his mother,
Carolina, left him in her den until early
April. When we made this, his first
portrait, he had never had a good view
of people. His expression seems to
say he did not know what to think.

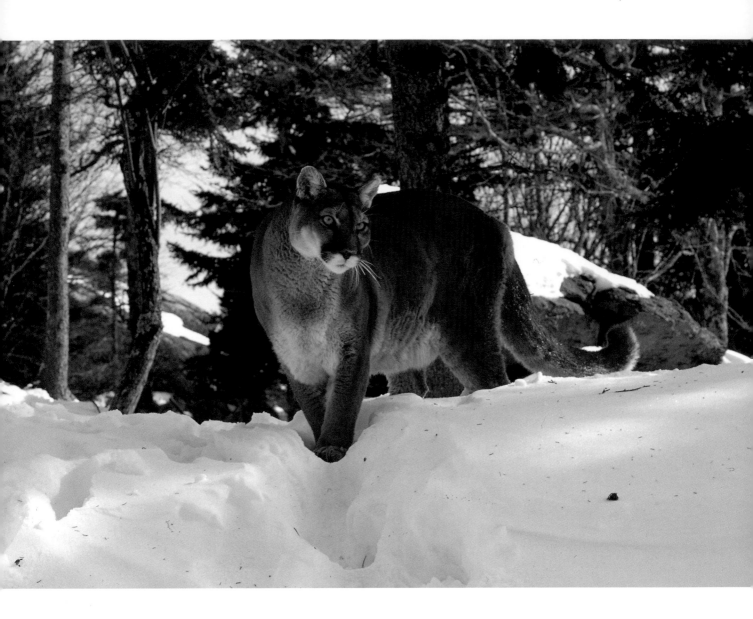

Panther, cougar, mountain lion —
it is all the same animal. Wildlife
authorities class an animal as extinct
when there are no mating pairs in the
wild. That is the case in the eastern
United States, except for a very few
panthers in the wild in Florida.

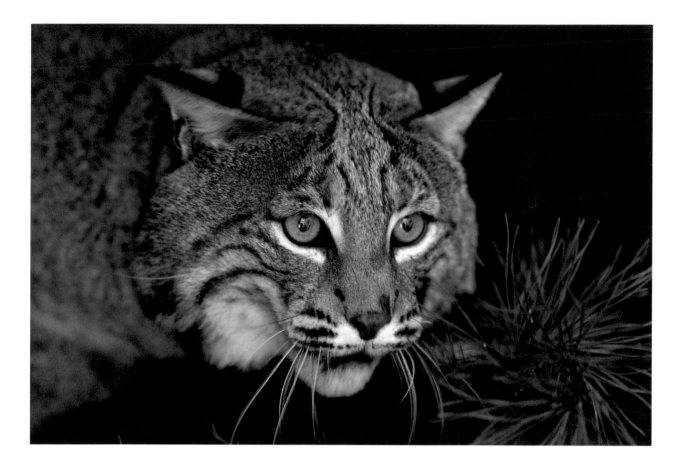

The bobcat, a nocturnal animal very seldom seen. It thrives in wooded areas, from one end of North Carolina to the other.

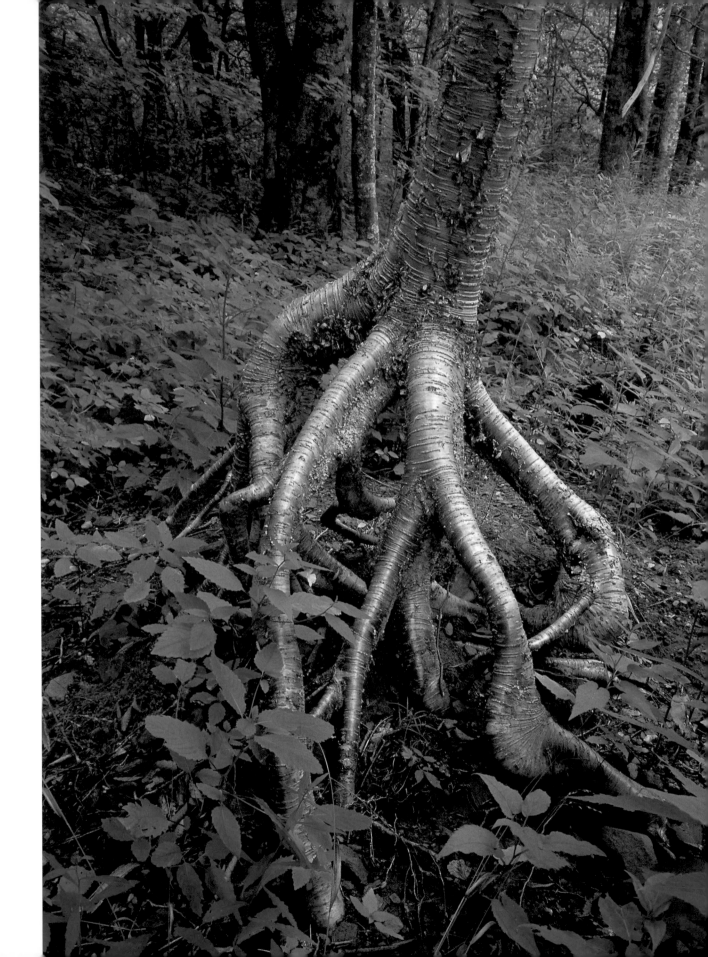

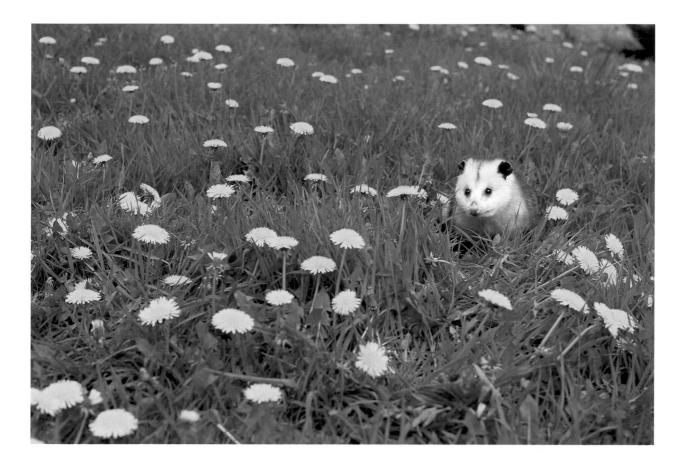

opposite:

A shoot came up from a yellow birch
stump, then roots from the new shoot
ran across the stump to the ground.
When the stump rotted away, the roots
of the new young tree were in midair
yet still providing nourishment.

The opossum is also essentially a
night roamer, but this young 'possum
is having an enjoyable time romping
in a patch of dandelions in broad
daylight.

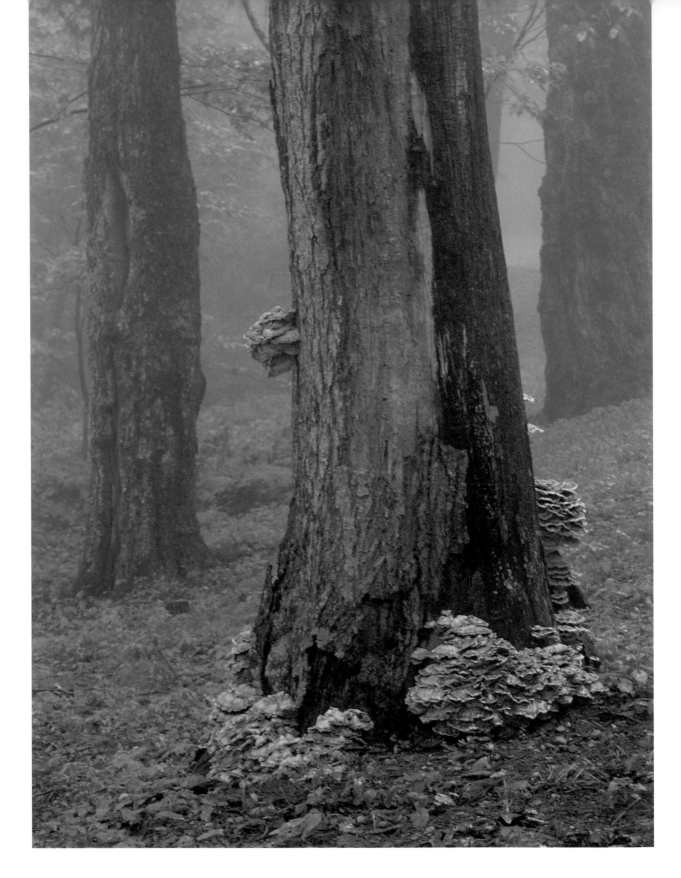

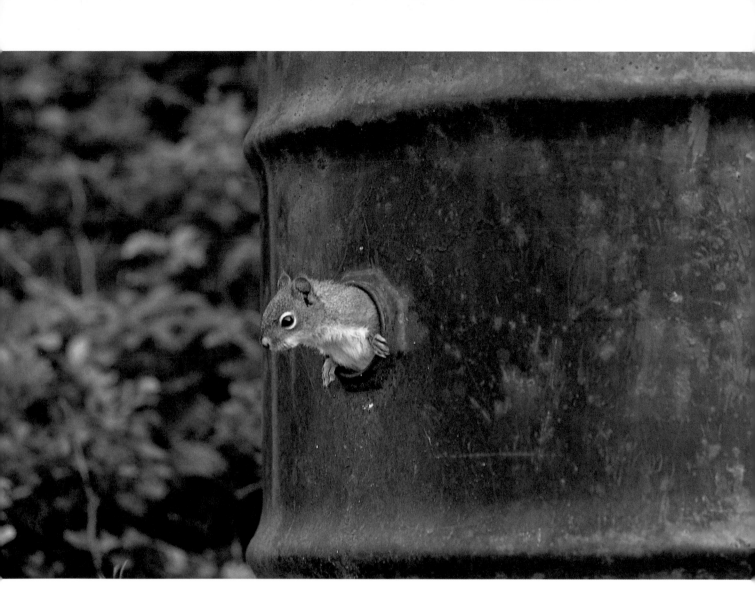

opposite:
Sulfur mushrooms around the base of
an oak that is either sick or dying.

Red squirrel or mountain boomer.
An old oil drum has been put to good
use as a trash can, and it is a dining
hall with a window for this squirrel.

Cinnamon fern, a tall, handsome
fern that is fairly abundant in the
North Carolina mountains.

opposite:
Gray's lily (*Lilium grayi*), a rare native
plant found in a few North Carolina
mountain counties. It was named by a
fellow botanist to honor noted Harvard
professor Asa Gray, who did extensive
exploration in North Carolina.

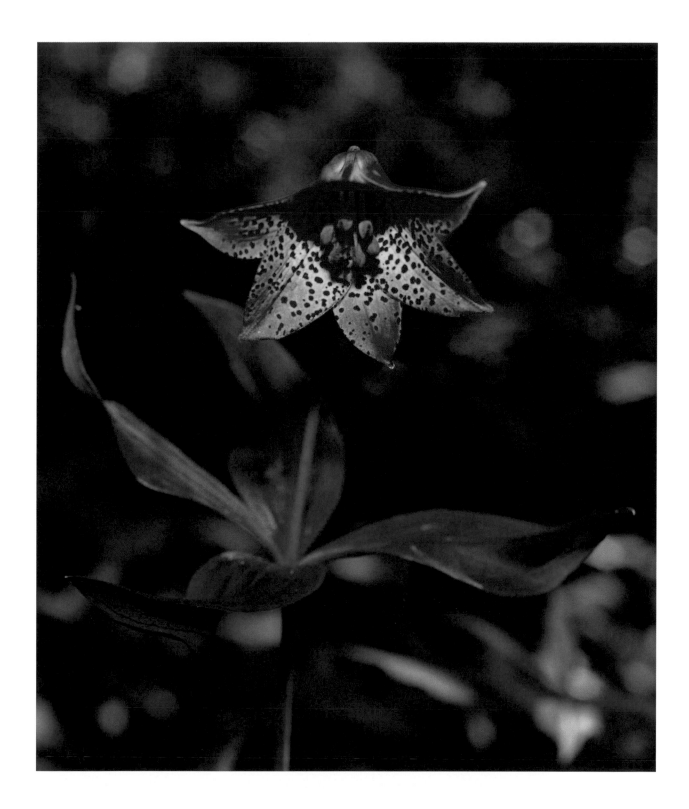

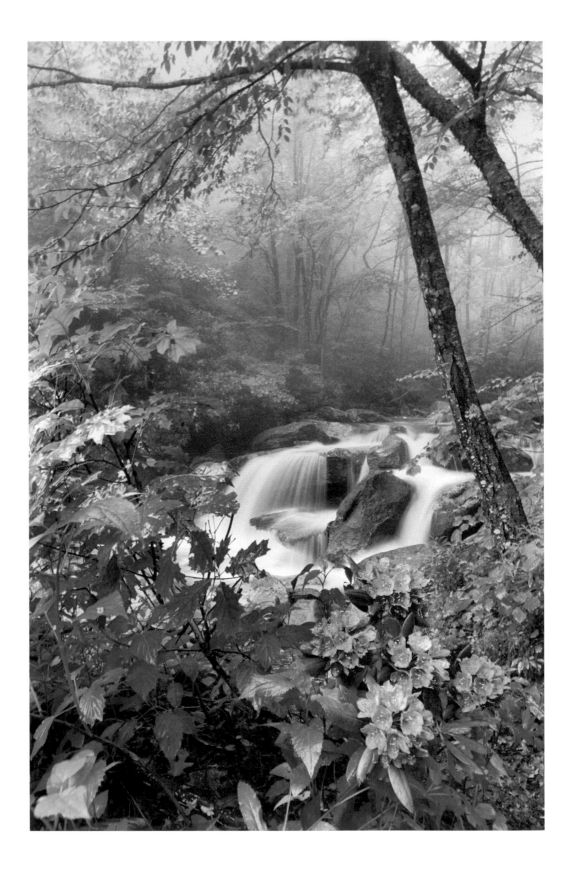

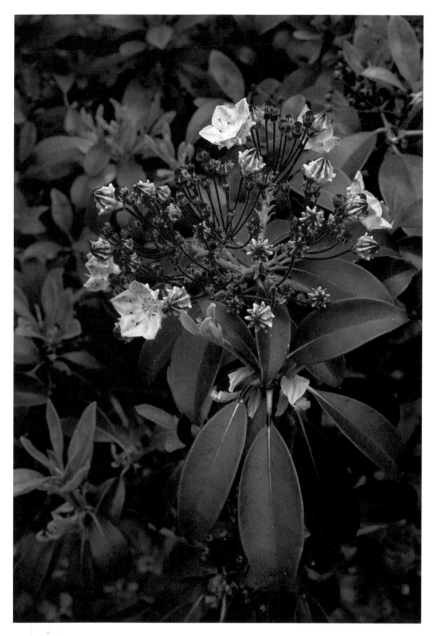

Colorful buds and blossoms of the mountain laurel. The plant blooms from April to June.

opposite:
The rocky headwaters of Wilson Creek, which flows off of Grandfather Mountain through Pisgah National Forest and Daniel Boone Wildlife Refuge.

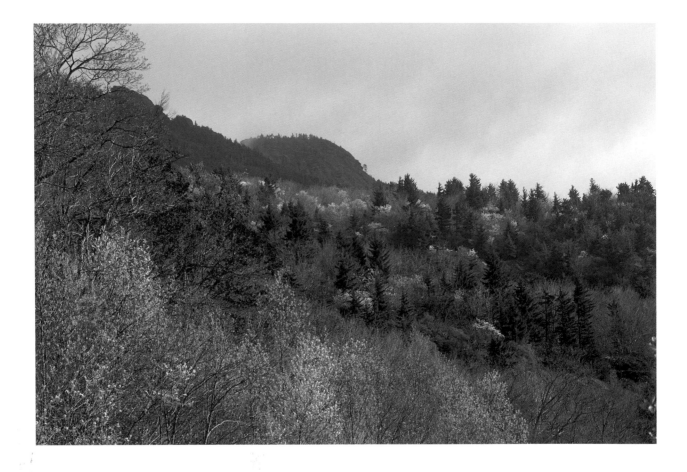

Springtime color near the Beacon
Heights intersection of the Blue Ridge
Parkway and U.S. 221. The reds are
maples spreading their new leaves,
and the whites are the bloom of the
service tree.

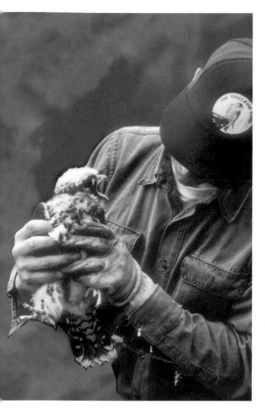

The peregrine falcon, once considered extinct in North Carolina, is being reintroduced by state and federal wildlife agencies, in cooperation with the Peregrine Fund.

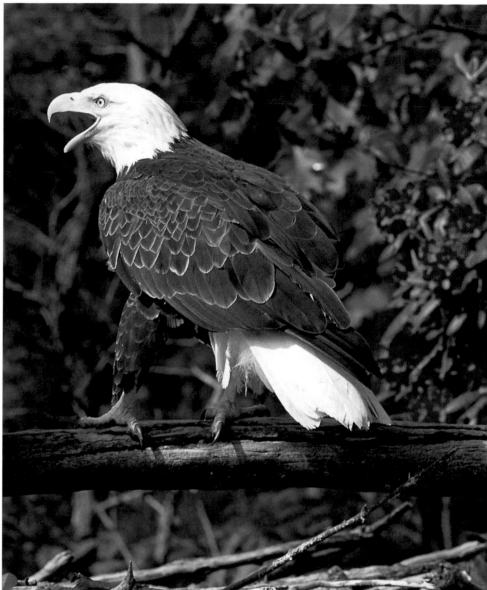

Bald eagle. This bird was injured and cannot fly, but as the emblem bird of the United States she is greatly admired in the Grandfather Mountain eagle habitat.

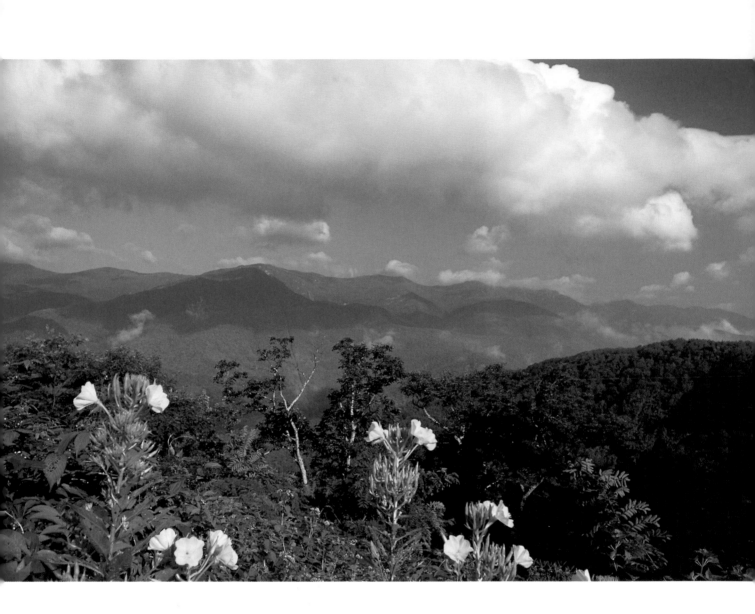

Summertime clouds over the Black
Mountain range and Mount Mitchell.
Yellow false evening primrose peps
up the foreground.

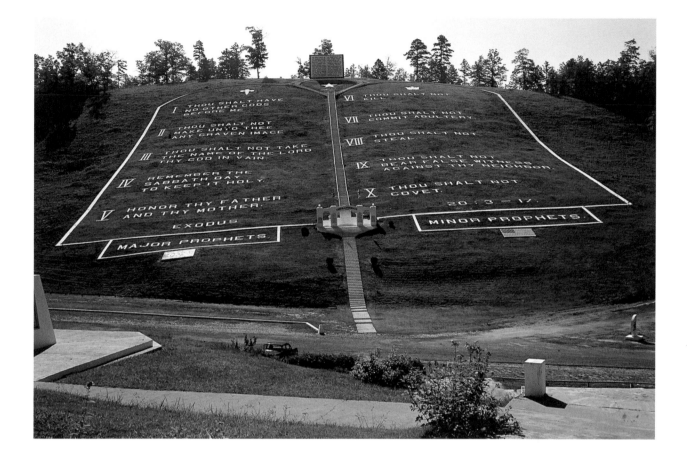

The Ten Commandments, in Fields
of the Wood Park, near Murphy, N.C.
Erected in 1942 by the Church of God
Prophecy, the commandments attract
300,000 visitors annually from a
number of denominations and faiths.

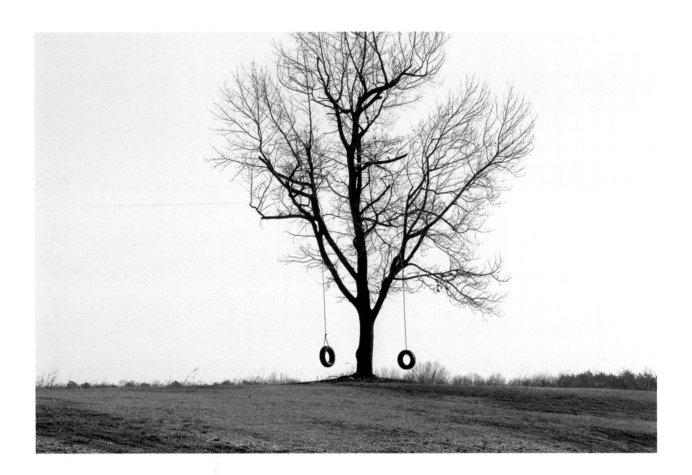

Tree swing near Dallas, N.C.,
in Gaston County. Dallas was the
boyhood home of William Friday,
president emeritus of the University
of North Carolina.

opposite:
Whitetail fawn and a puddle of
fresh rainwater.

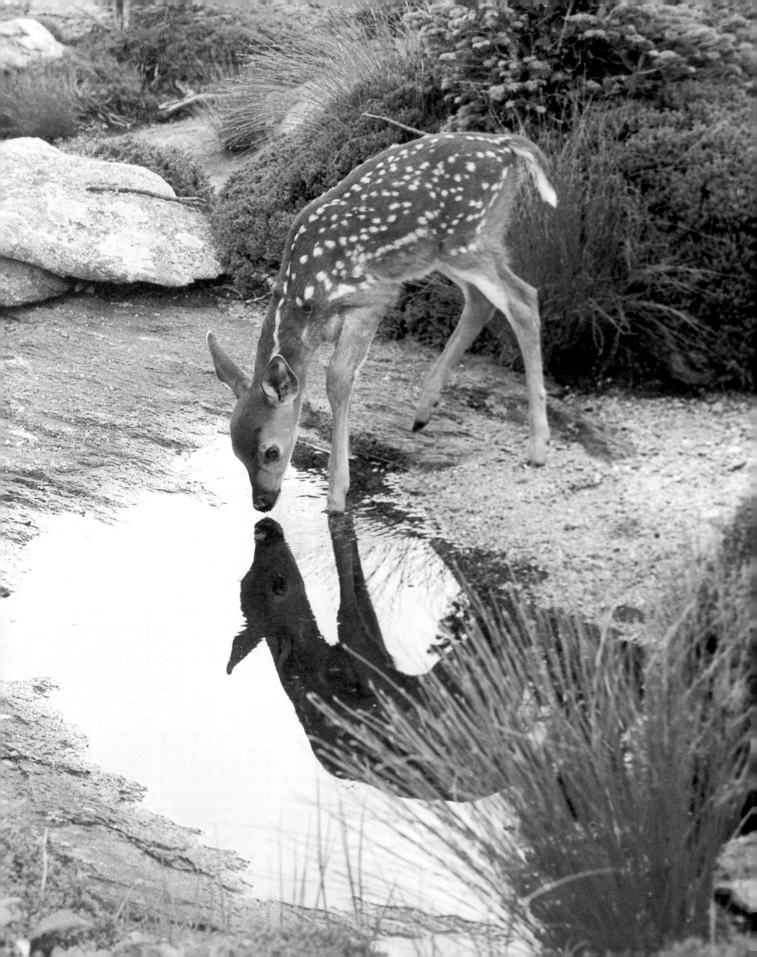

The N.C. Board of Transportation received frequent commendation for constructing and maintaining highways, yet members of that board have told us many times that one of their most popular programs is planting flowers along our highways.

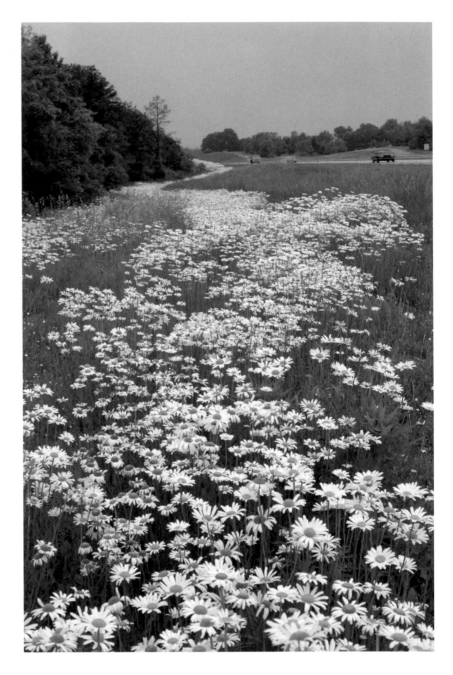

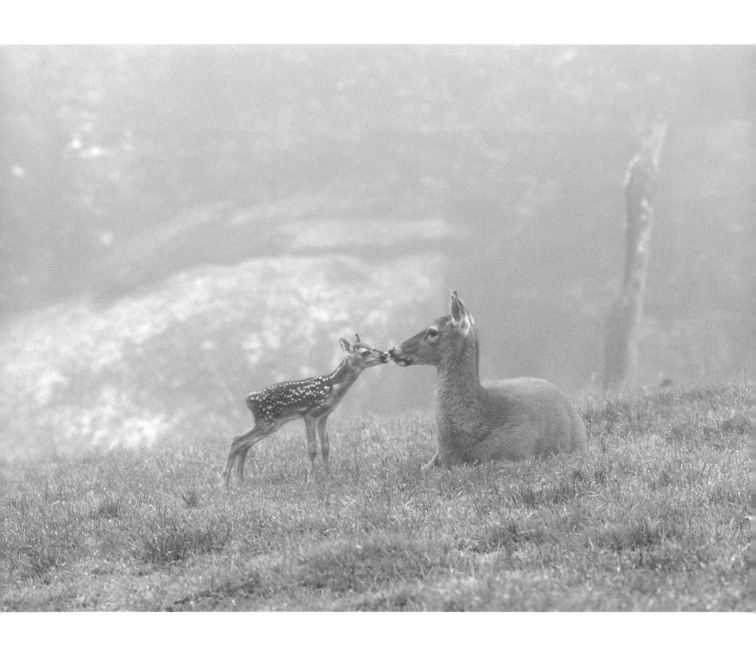

Fawn and mother.

The leaves of the sassafras tree.

In years following World War II, road builders were blessed with modern new equipment that made possible skinning off roadside banks with relative ease. When fishing streams and water supplies became silted at an alarming pace, erosion fences and other environmental protection became necessary.

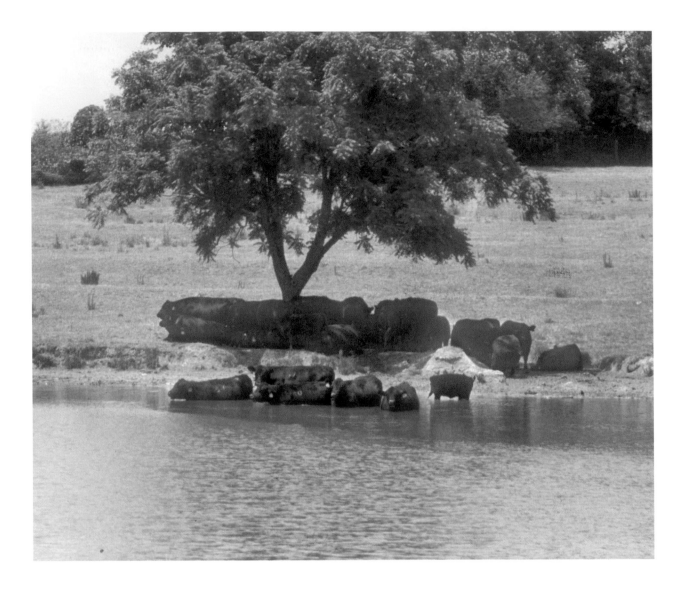

Black Angus cows seeking relief from
the ninety-degree heat in a farm pond
near Cherryville.

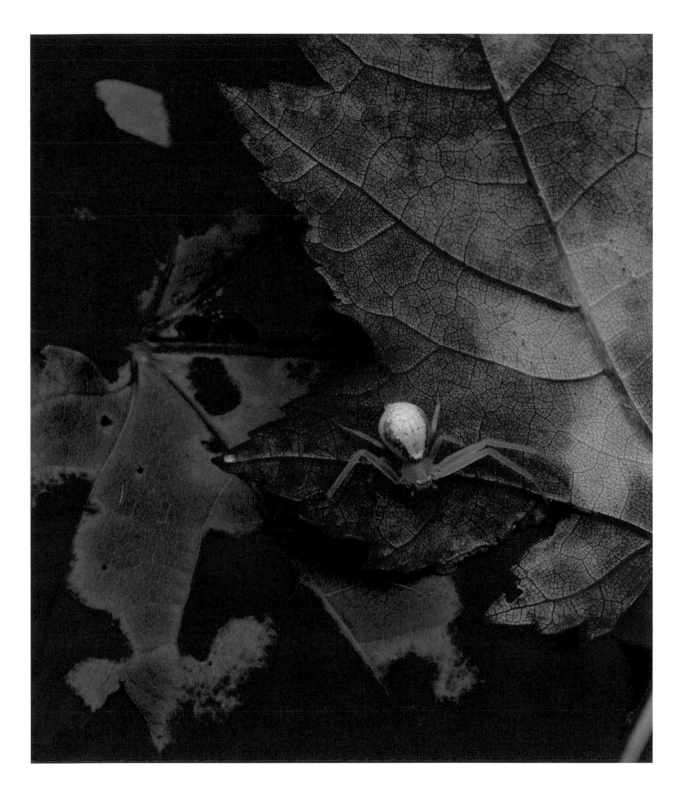

Goldenrod spider on a background of
fall-colored maple.

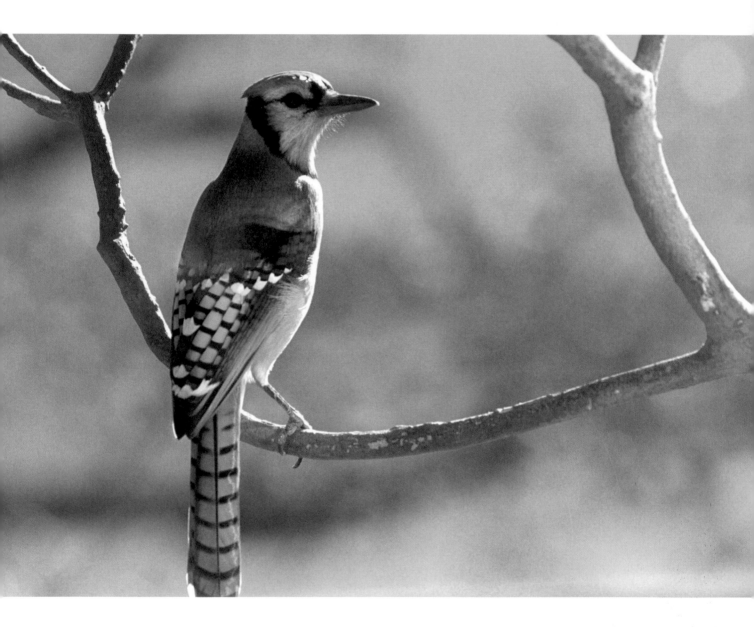

Blue jay.

opposite:
Great horned owl. Principally nocturnal, it is large enough to prey on animals as big as skunks.

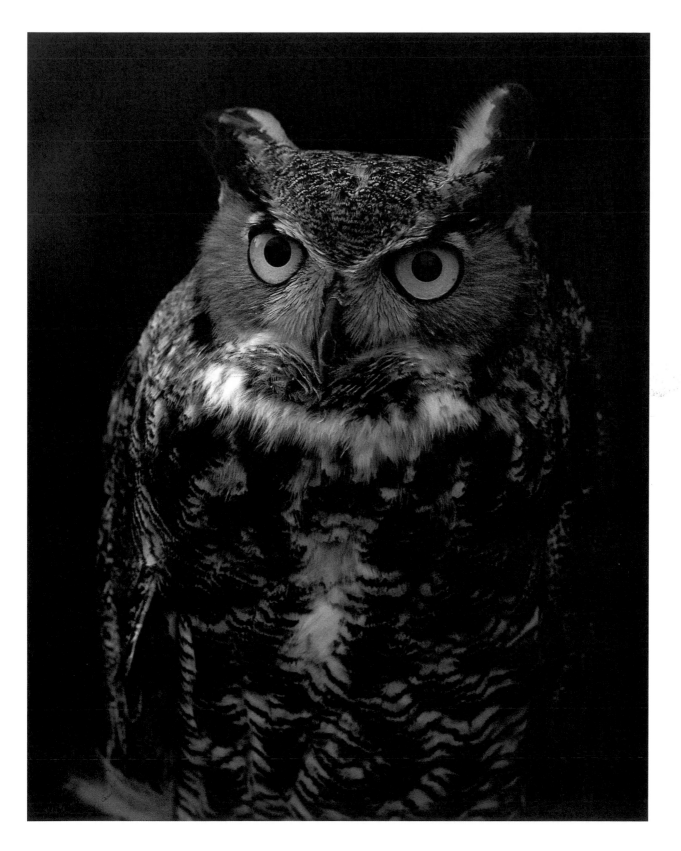

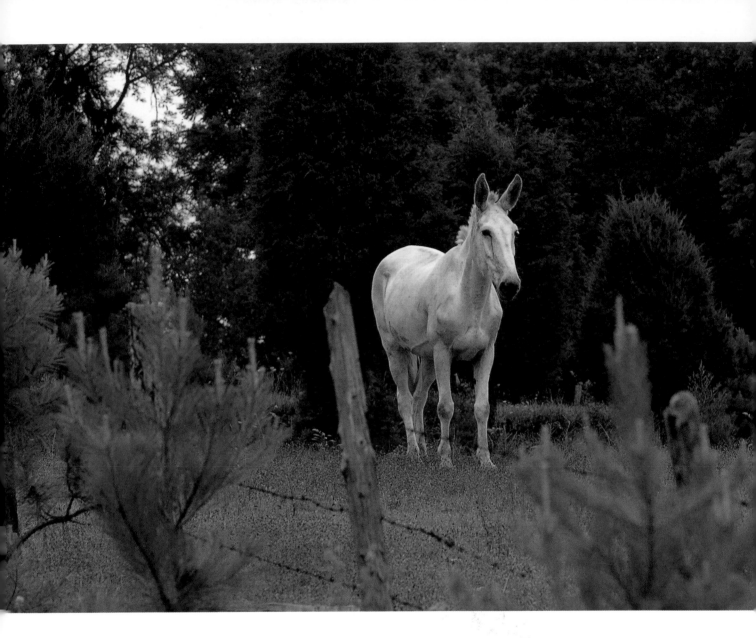

Mule at fence.

opposite:
An alert, long-legged colt.

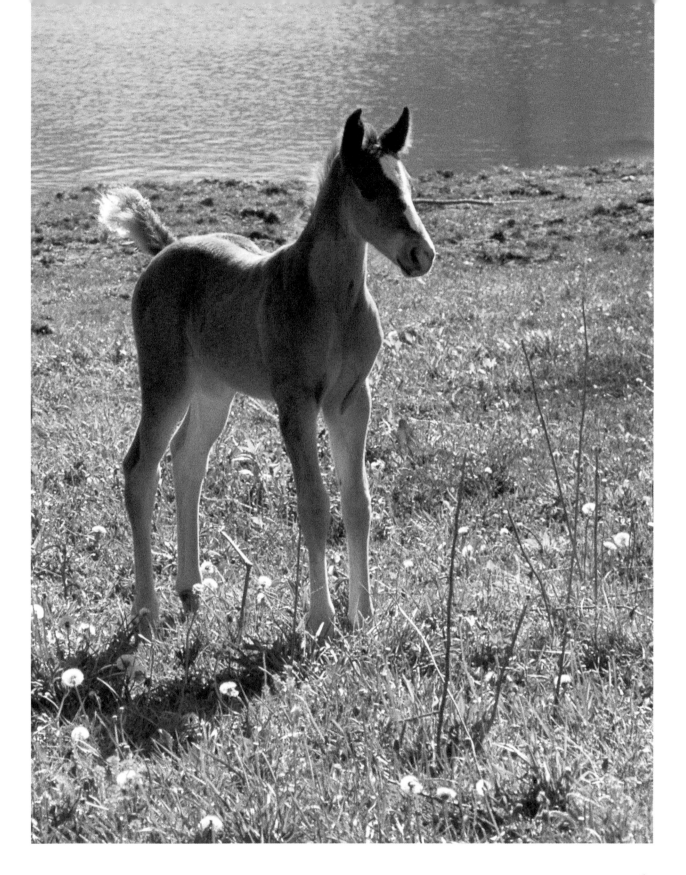

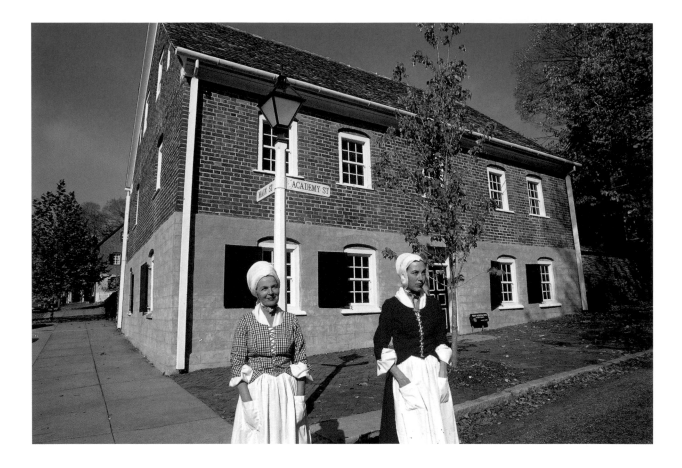

Old Salem. A major tourist
attraction for the Winston-Salem
area, Old Salem is also one of
the leading historic preservation
projects in North Carolina.

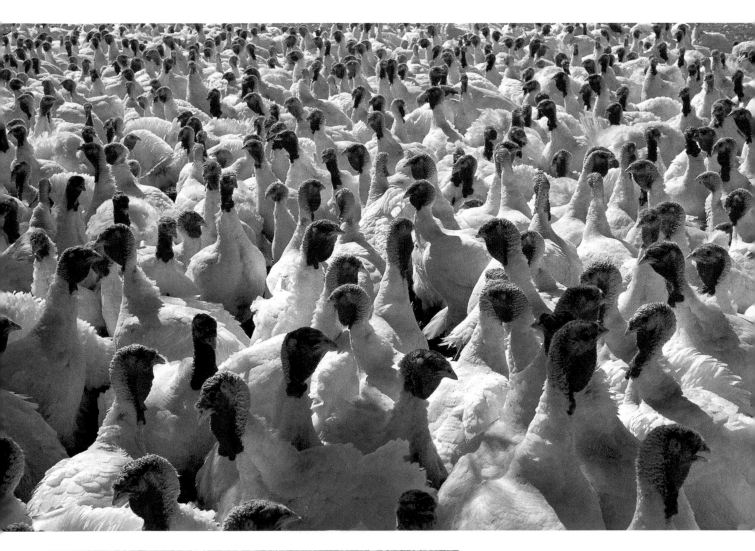

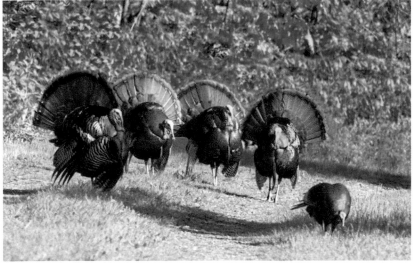

top:
Turkeys on a Wadesboro farm.

bottom:
Four male wild turkeys marching abreast, strutting for one hen, who is obviously giving them the cold shoulder.

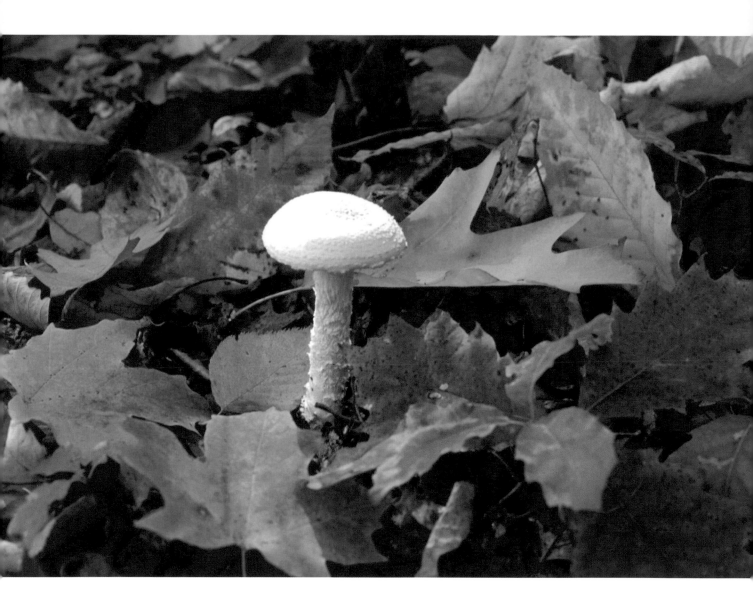

Fly agaric mushroom, in the death
cap family. Common throughout the
southern Appalachians, it is rarely
fatal but very poisonous.

opposite:
Solitary doves are scarce. They
are more inclined to stick together
in flocks, particularly during
roosting times.

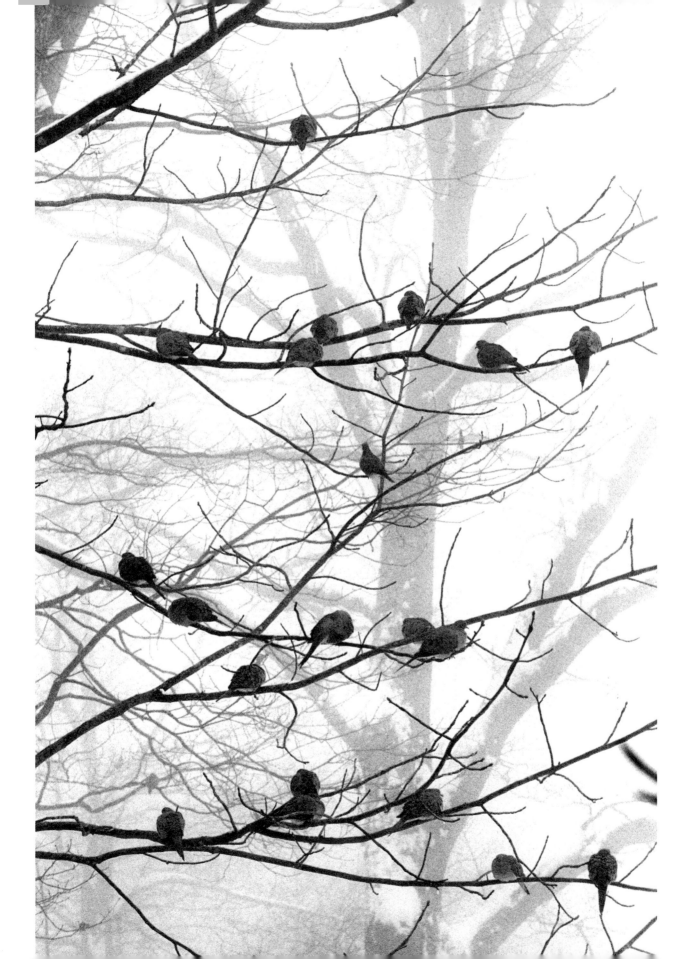

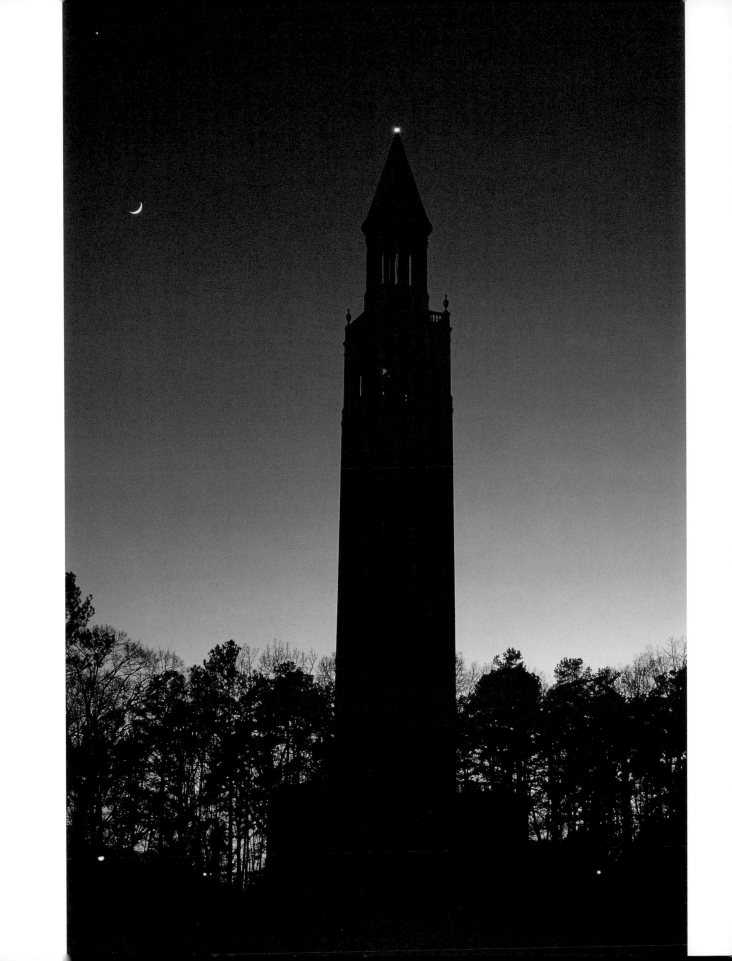

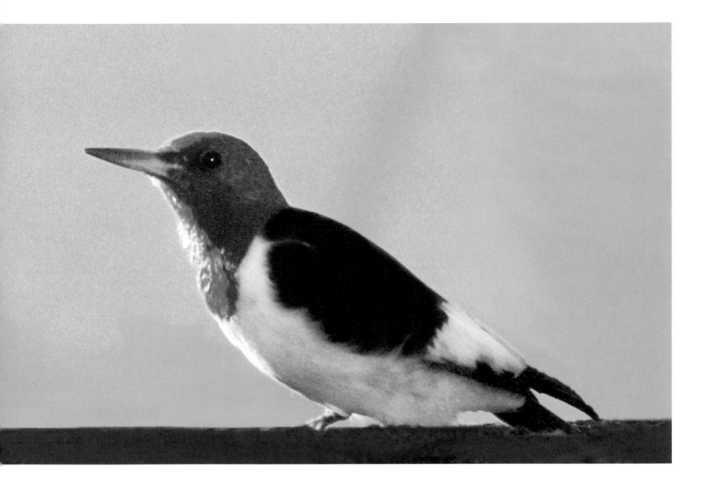

opposite:
Morehead-Patterson Bell Tower, one
of the great landmarks on the campus
of the University of North Carolina.

Red-headed woodpecker.

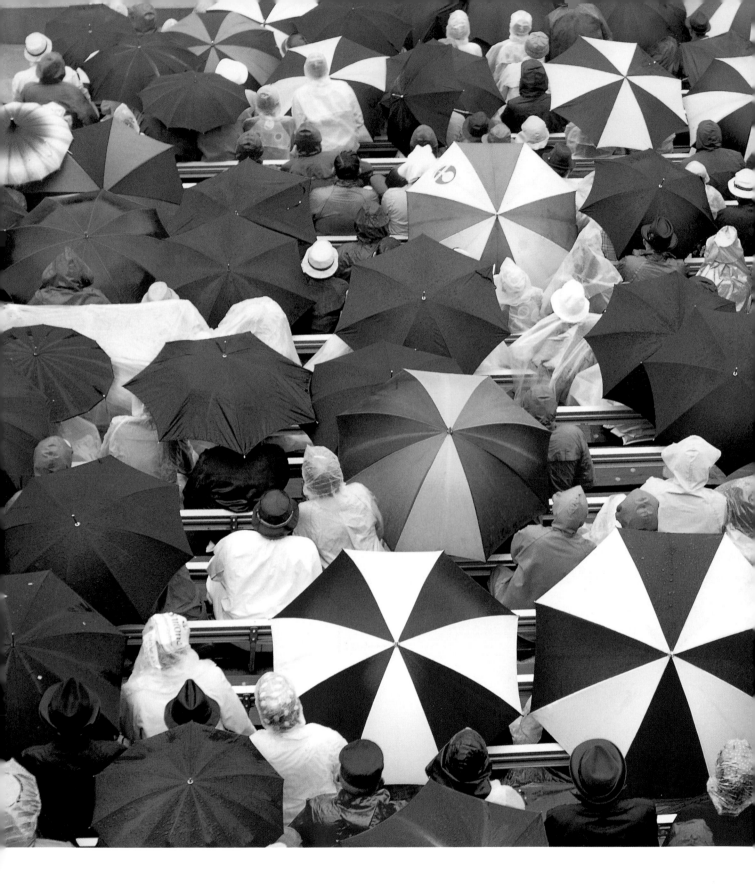

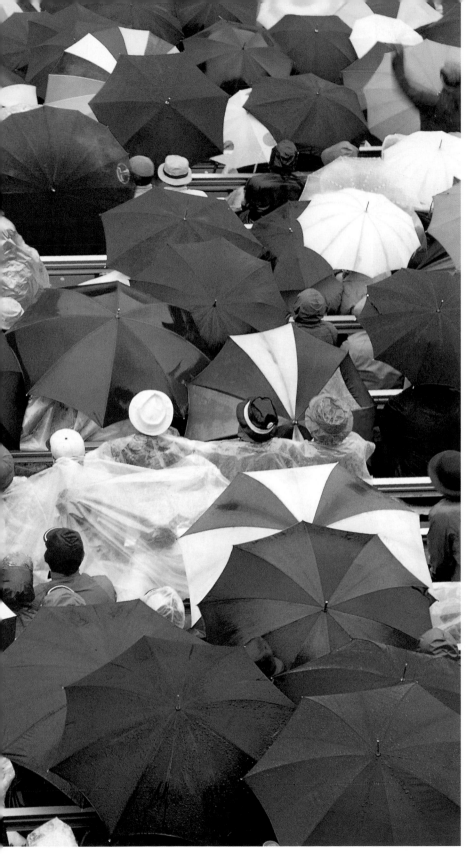

Umbrellas on a rainy day in
Kenan Stadium.

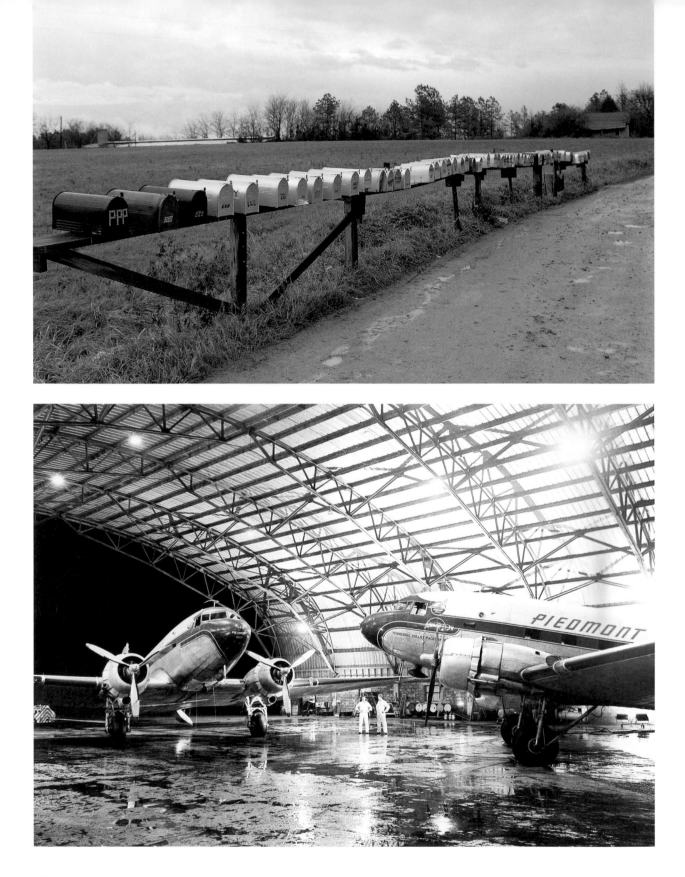

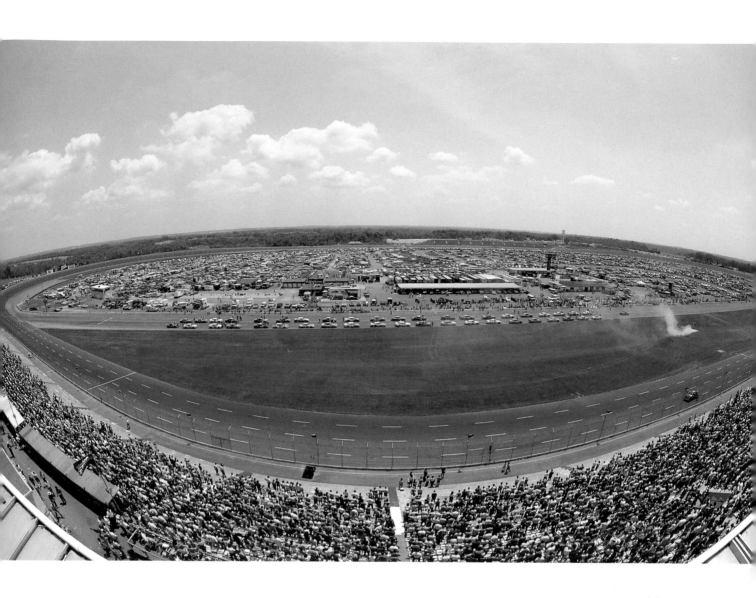

opposite, top:
This colony of mailboxes lined a rural road off U.S. 15-501 between Sanford and Chapel Hill. We imagine the mail carrier serving these customers had to be careful not to drop a letter or two in the wrong box.

opposite, bottom:
This pair of DC-3's in the hangar at Wilmington was the entire Piedmont fleet when the airline was founded in 1948. The whole route at that time consisted of thirteen stops, including Wilmington and Cincinnati.

Lowe's Motor Speedway. In 1983, when this picture was made, the speedway seated approximately 100,000; in 2005 it had 152,000 seats and could accommodate about 25,000 people in the infield, by far the largest crowd that can be assembled in the state.

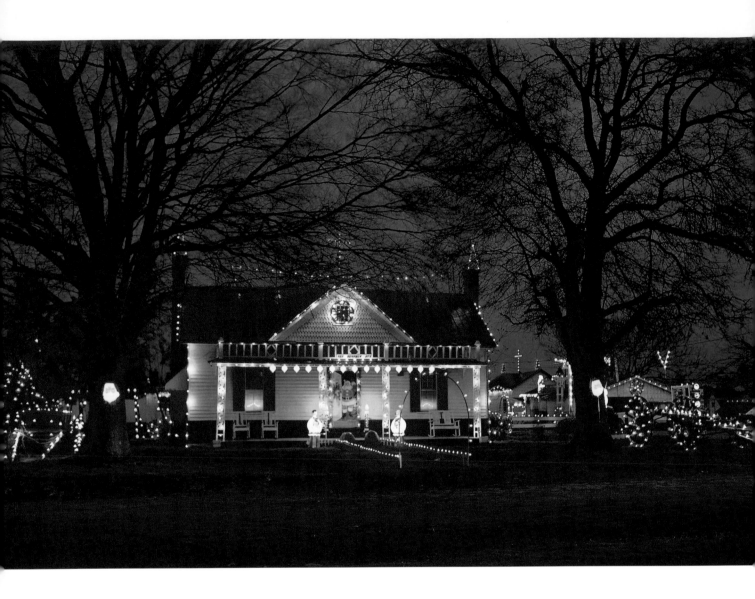

A demonstration of Christmas spirit
in Smithfield, Johnston County.

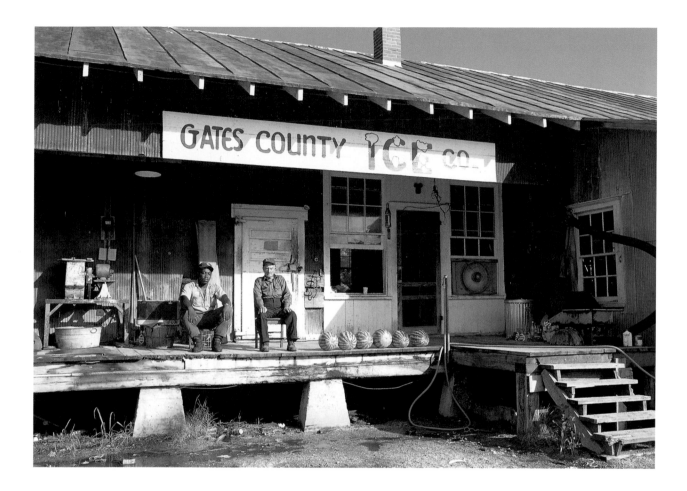

When electric refrigerators became plentiful in Gates County and big blocks of ice were not as much in demand, Gates County Ice Company diversified by selling watermelons.

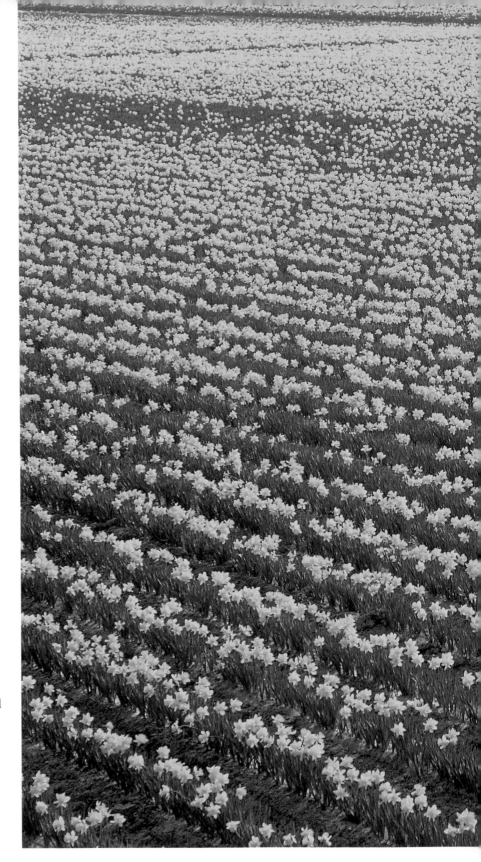

Julia Morton and daughter
Catherine enjoying a close-up
view of daffodils in April 1969. My
grandfather, Hugh MacRae, developed
the farm community of Castle Hayne
near Wilmington and helped farmers
from Holland become established in
intensive farming of ten-acre plots.
One highly successful crop was
daffodils, shipped to florists in the
northern United States.

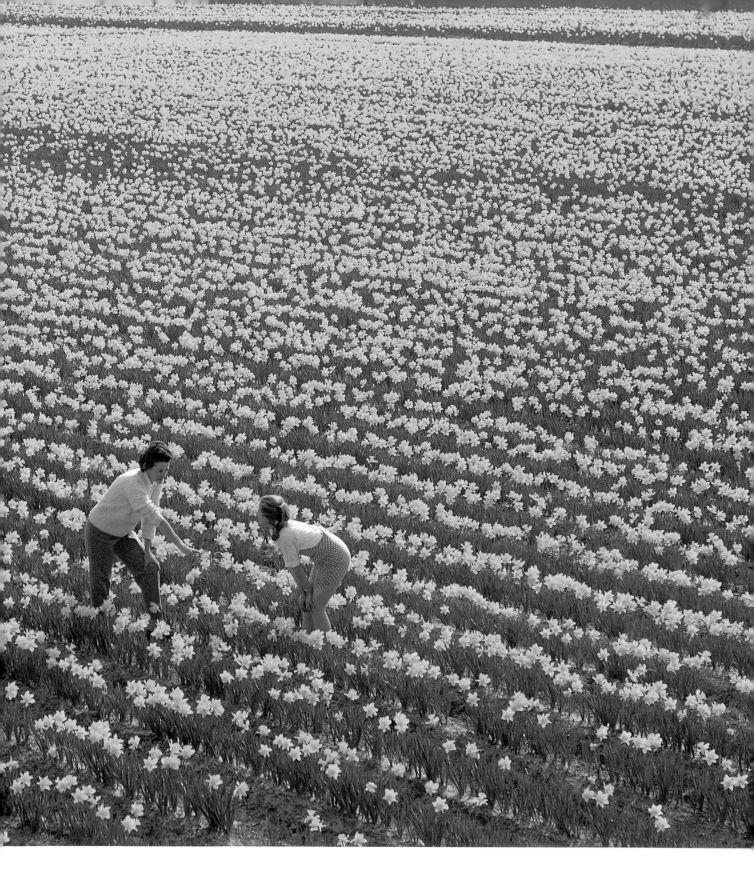

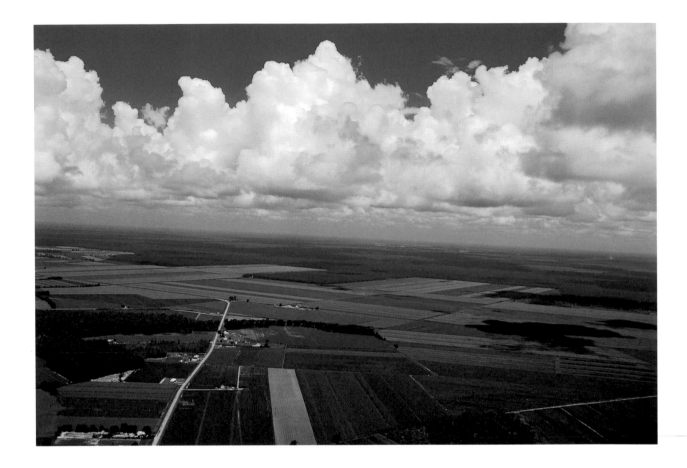

Coastal Plain scene near Elizabeth City
in the northeast part of the state.

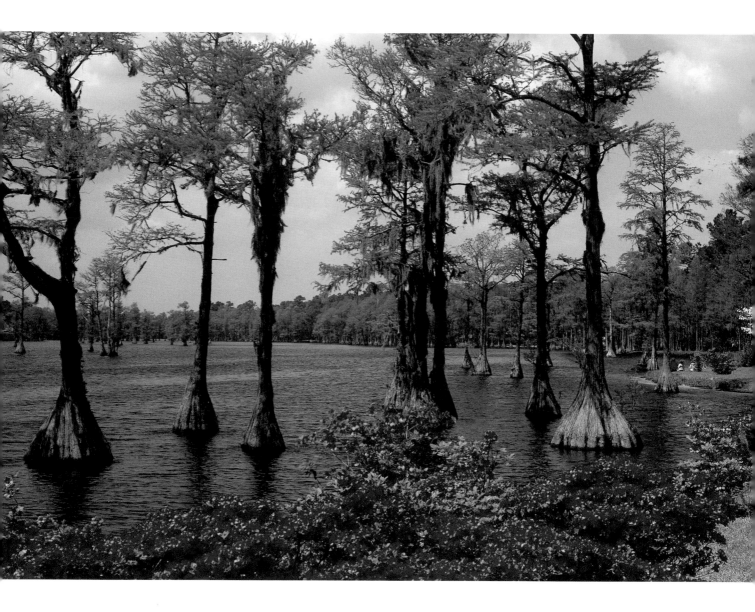

Greenfield Gardens. Greenfield,
Orton Plantation Gardens, and Airlie
Gardens together had more than a
million azaleas when Wilmington
held the first azalea festival in 1948,
so the slogan was "More Than a
Million Azaleas." It would not be an
exaggeration to say that Wilmington
has 10 million azaleas now.

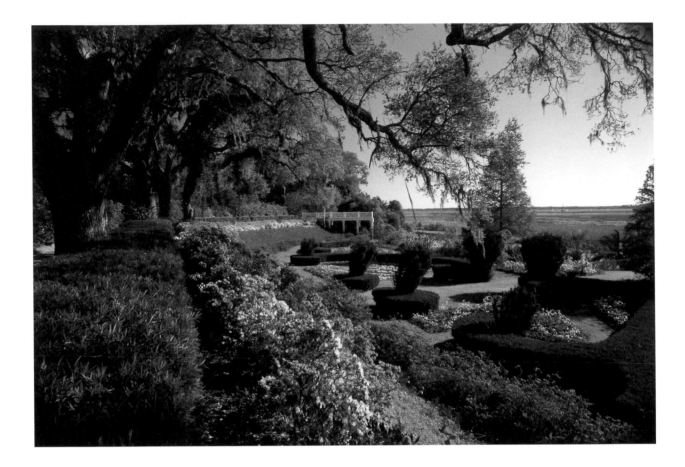

The formal gardens at Orton
mansion in Brunswick County
feature azaleas, pansies, camellias,
and shrubs that add color to the
scene. Beyond are rice fields from
colonial times, and the Cape Fear
River is east of the rice fields.

opposite:
Post office on Harkers Island.
Floyd Yeomans was postmaster
some fifty years ago, and his
daughter Susanne, age six, is
standing beside the building.

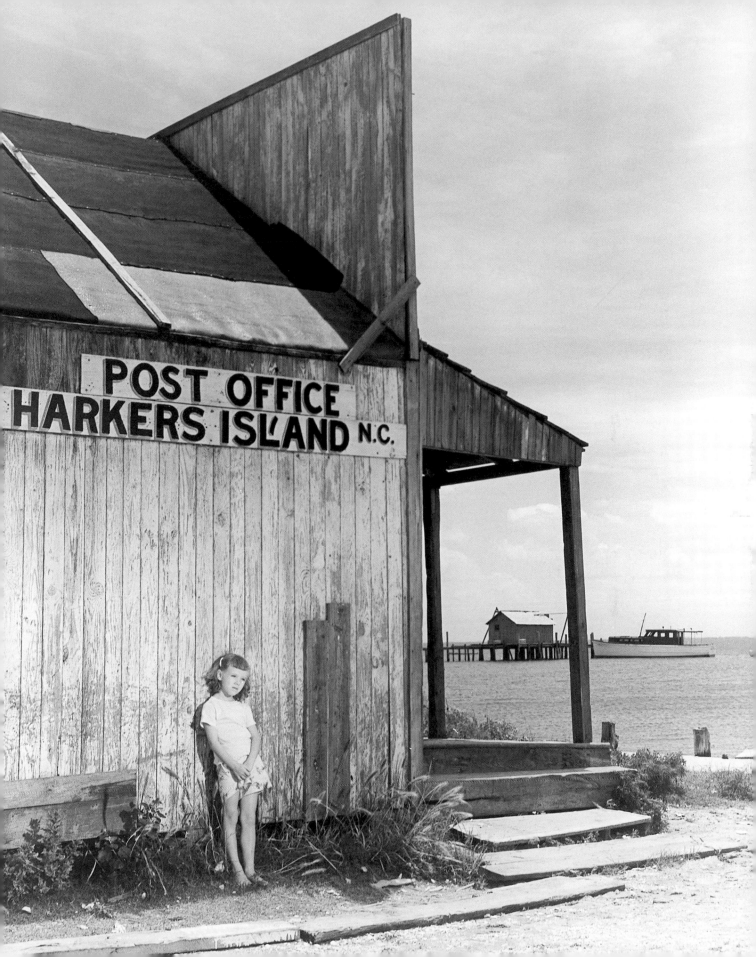

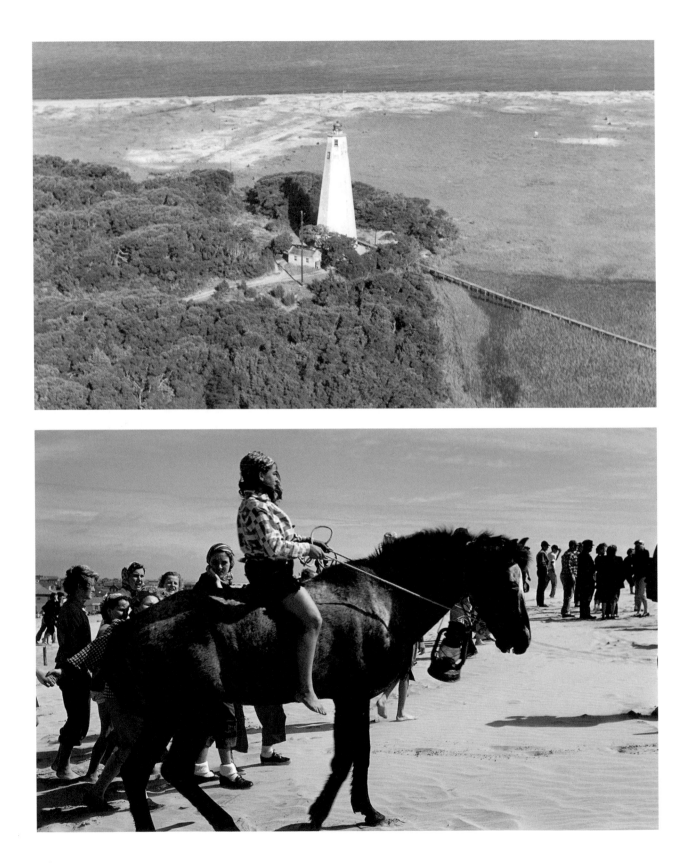

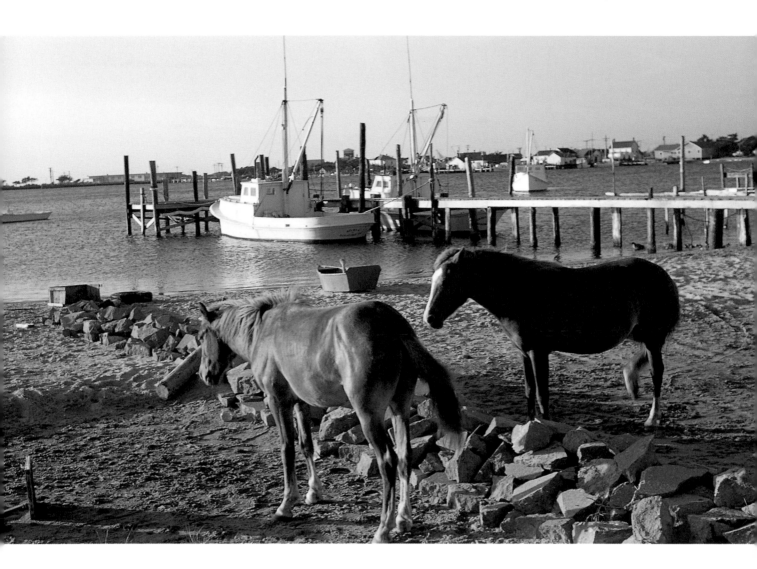

opposite, top:
Cape Fear Lighthouse on Bald Head
Island directly across the mouth of the
Cape Fear River from Southport. For
many years this beacon guided ocean
traffic into the Cape Fear River ship
channel leading to Wilmington thirty
miles upstream.

opposite, bottom:
Reenactment of the nag tale at
Nags Head, Dare County, 1950s.
In the 1800s shipwreck salvagers,
or "shipbusters, I will," were said to
tie a lantern to a nag's head, and
the moving light confused offshore
ships and drew them into the shoals.
The shipbusters would then salvage
the wreck.

Outer Banks ponies on the
Silver Lake waterfront at Ocracoke.
According to local historian Danny
Couch, these ponies "are true,
purebred ponies, based on the
chestnut brown color produced by
400 years of close breeding."

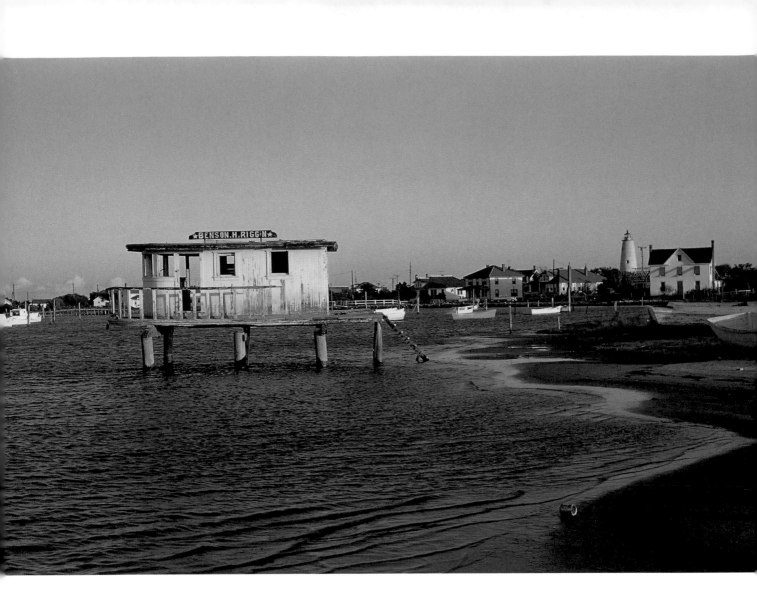

Wheelhouse of a Pamlico Sound
freight boat mounted on stilts,
a tourist attraction on the Silver
Lake waterfront at Ocracoke in the
late 1950s. The Benson H. Riggs
nameplate came from another
schooner. In the background at
the right is Ocracoke Lighthouse,
built in 1823, the oldest operating
lighthouse in North Carolina.

opposite:
Bodie Island Lighthouse north
of Oregon Inlet and Hatteras Island,
completed in 1872 after faulty
construction caused earlier attempts
to build a lighthouse there to fail.
Its daylight markings make it easily
distinguished from lighthouses at
Hatteras and Cape Lookout, which
are of similar construction.

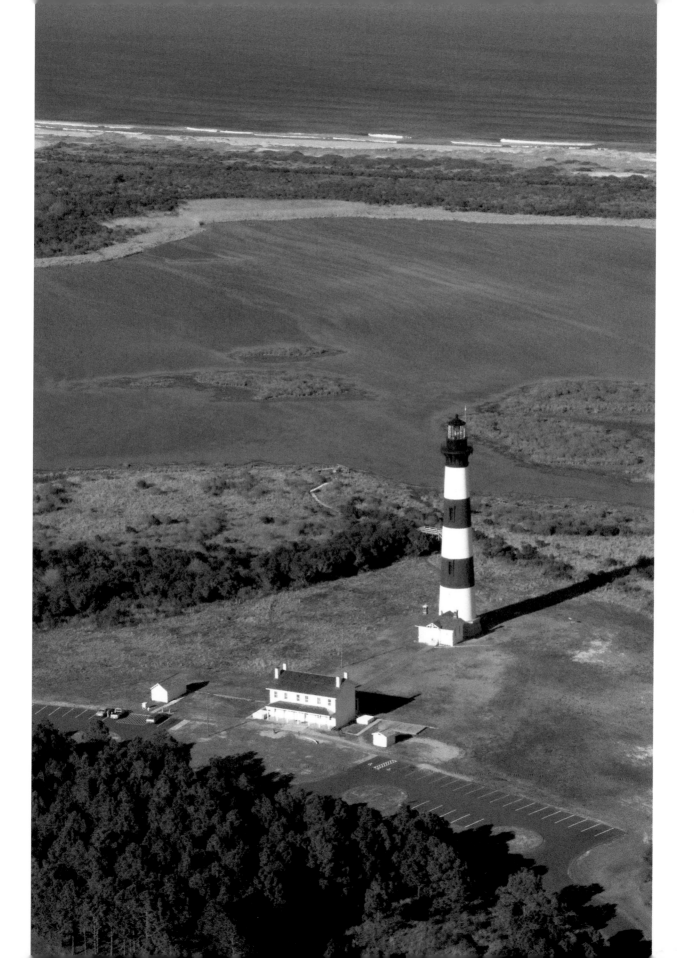

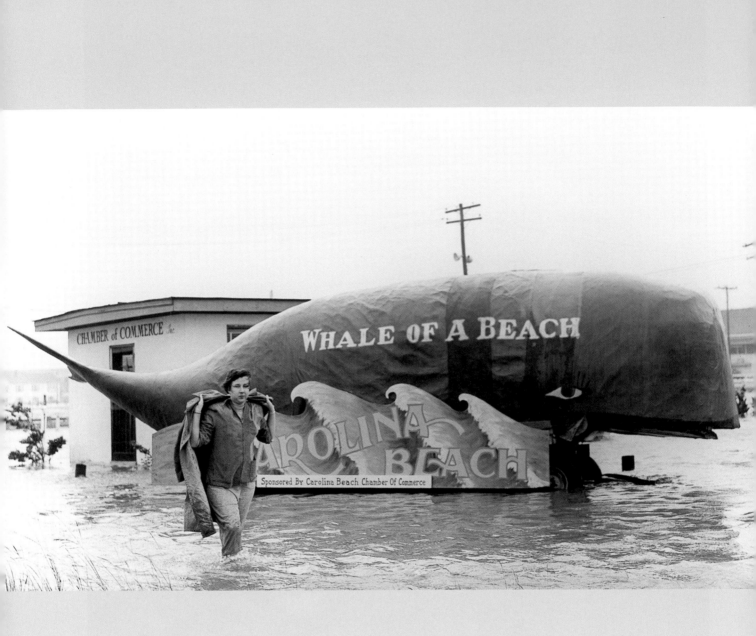

Carolina Beach had an attractive float in April 1954 for the Azalea Festival Parade in Wilmington, and it was so popular that it was stored in front of the chamber of commerce. When the center of hurricane Hazel came ashore at Carolina Beach at full moon high tide in October, the float nearly floated in the rising tide of the greatest hurricane ever to hit southeastern North Carolina.

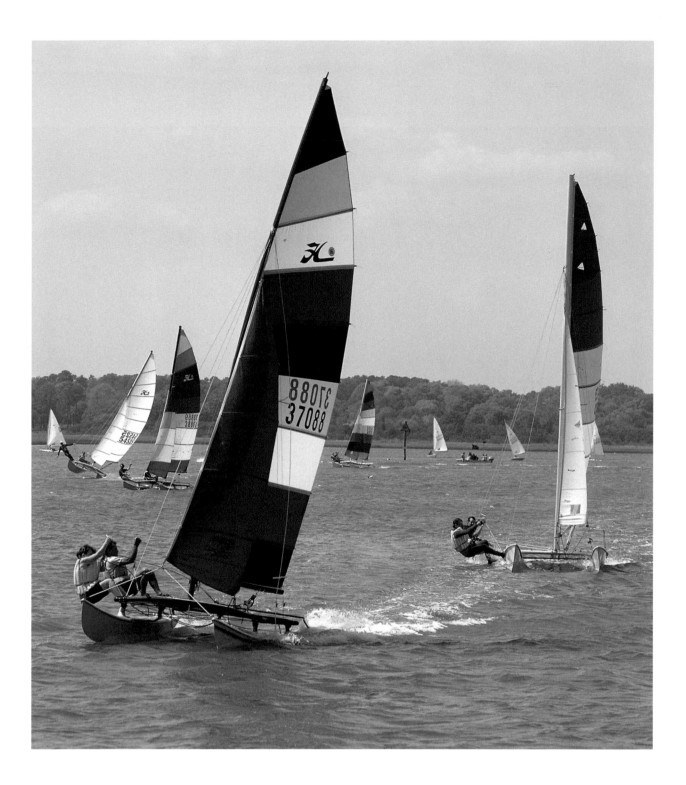

Brilliant shaded sailboats in the Hobie Cat class are shown here in competition in Banks Channel at the Carolina Yacht Club at Wrightsville Beach.

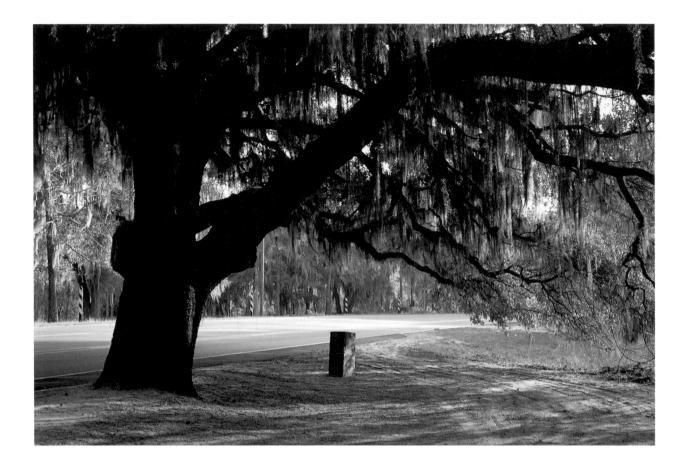

President George Washington
is said to have stopped for lunch
beneath this live oak on his way to
Wilmington. It stands about 10 miles
north of Wilmington on U.S. 17.
The stone was placed by the North
Carolina Daughters of the American
Revolution in 1925 to commemorate
the event.

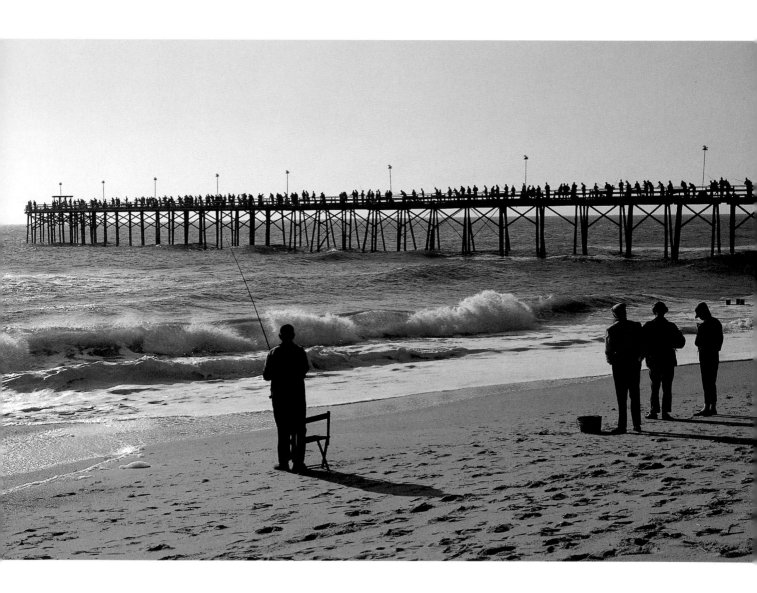

Lumina Pier, Wrightsville Beach.
There was hardly enough elbow room
for fishermen to make their casts in
October 1964.

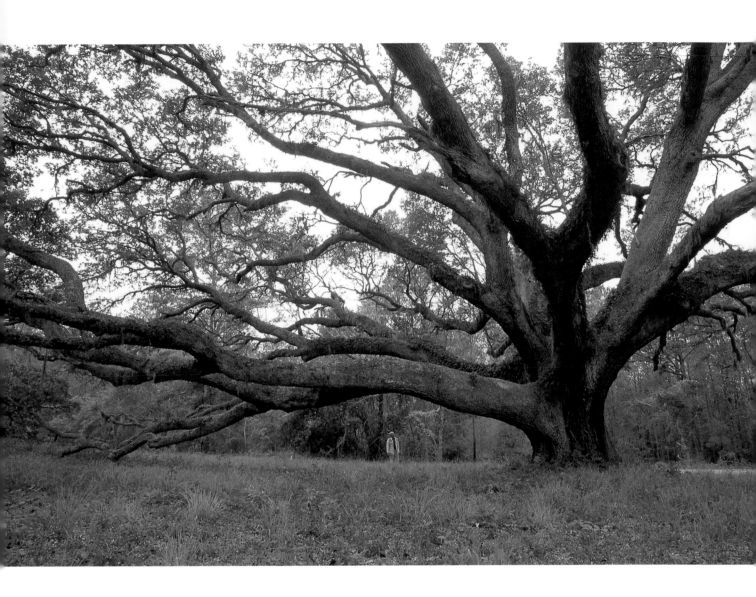

A magnificent live oak at the southern
end of Orton Plantation.

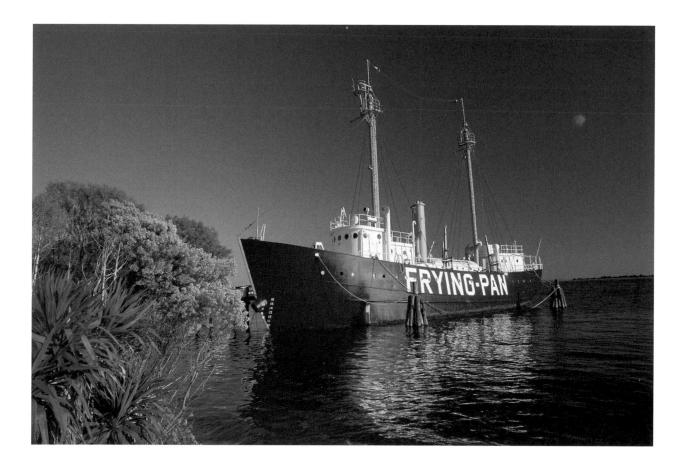

Frying-Pan Shoals Lightship, which
served ocean shipping off the mouth
of the Cape Fear River for many years.
After being decommissioned in 1974,
it was docked in Southport for a brief
time.

U.S. soldiers training with antiaircraft barrage balloons at Camp Davis. These balloons were never needed in the continental United States but were widely used in Great Britain. The photolab at Camp Davis, where I worked as an army photographer before becoming a combat cameraman in the Pacific, made pictures for British training manuals.

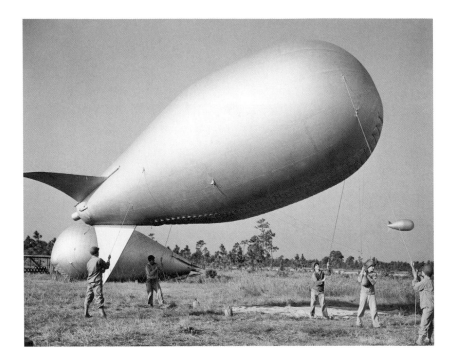

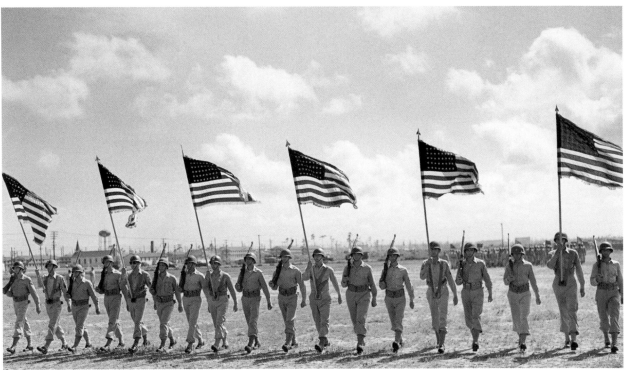

Camp Davis at Holly Ridge, thirty miles north of Wilmington, one of the major World War II army antiaircraft facilities in the country. All the flags were waving and every man was in step at the Armistice Day Parade on November 11, 1943, at Camp Davis.

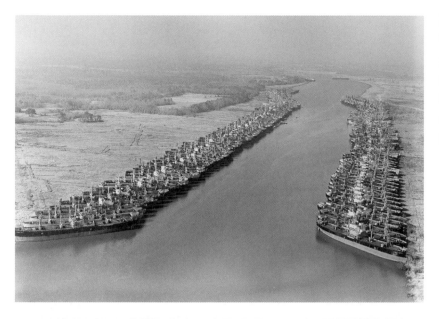

Brunswick River Layup Basin, near Wilmington. At one time as many as 500 merchant vessels, mainly Liberty ships, were stored there. The layup basin began receiving ships at the end of World War II, and all ships were sold or scrapped by the mid-1960s.

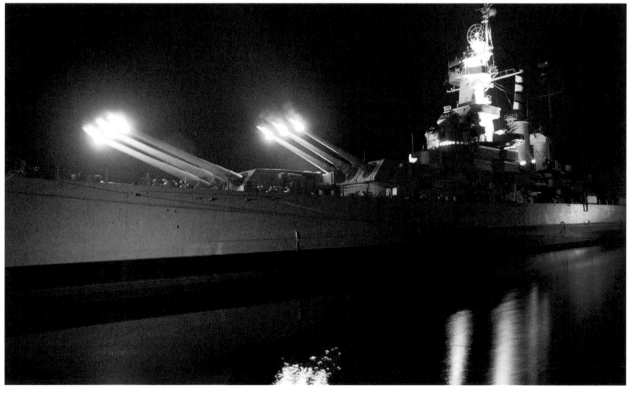

Battleship *North Carolina*. The sound and light show was the largest automated such show in the world when it was in operation in 1963. It involved dozens of lights and speakers and featured realistic muzzle blasts from the ship's huge sixteen-inch guns and recordings of the voices of President Franklin D. Roosevelt, Winston Churchill, and Adolf Hitler.

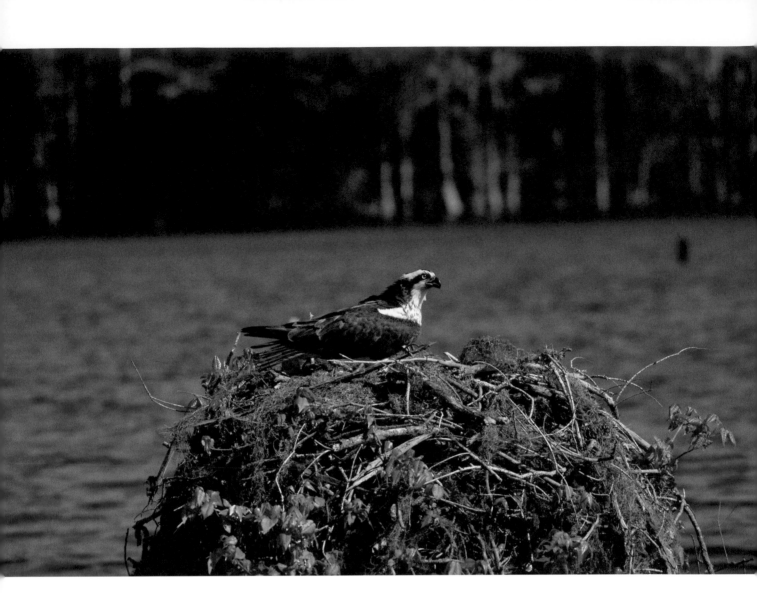

Osprey nest on Orton Pond in
Brunswick County. Built on a cypress
stump, it is used by the same bird
year after year. Now that use of
pesticides is strictly controlled, there
has been a good increase in the
number of ospreys.

North of the Wright Brothers
National Monument at Kitty Hawk is
a large granite marker at the actual
launch site of the world's first powered
flight. The flight was toward the
camera position of this photograph,
rather than toward the distant
monument on the hill.

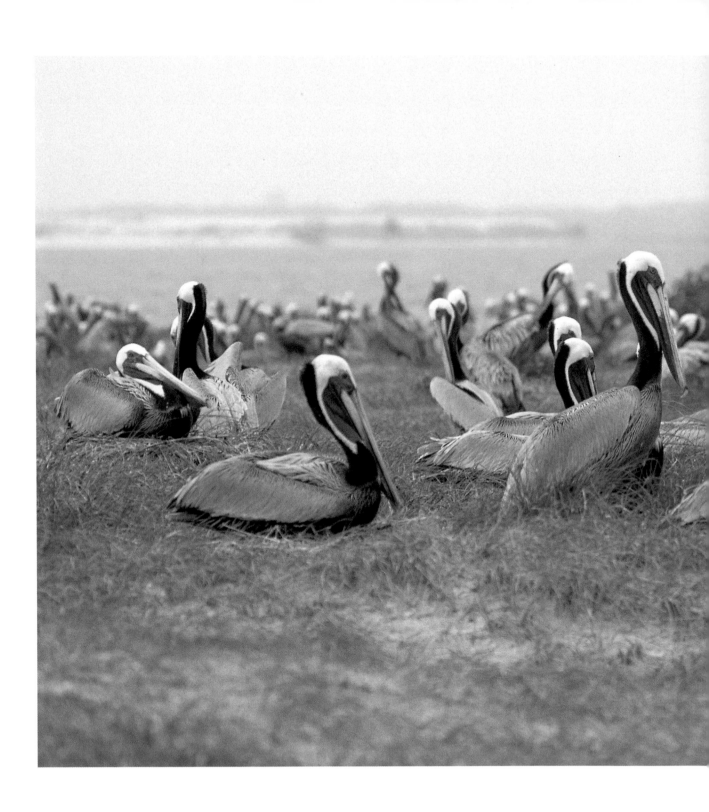

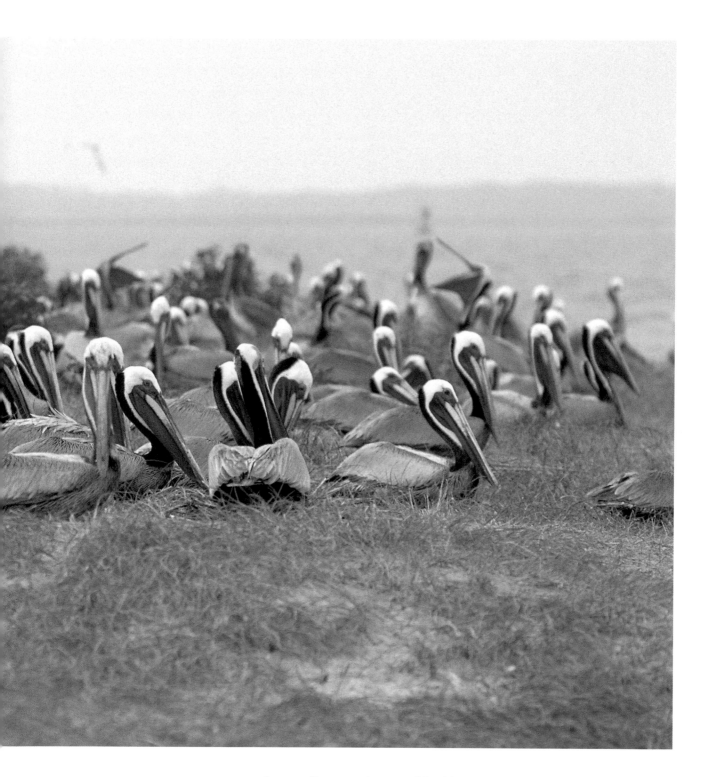

Brown pelicans nesting on an island formed by dredging the channel of the Cape Fear River below Wilmington. This bird has become considerably more plentiful on the North Carolina coast in recent years.

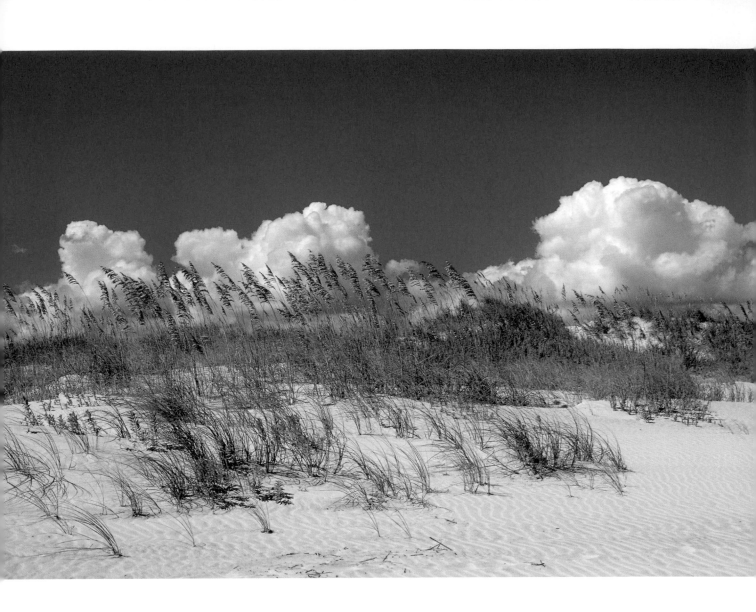

Clouds over Wrightsville Beach, at the
northern end, before it was developed.

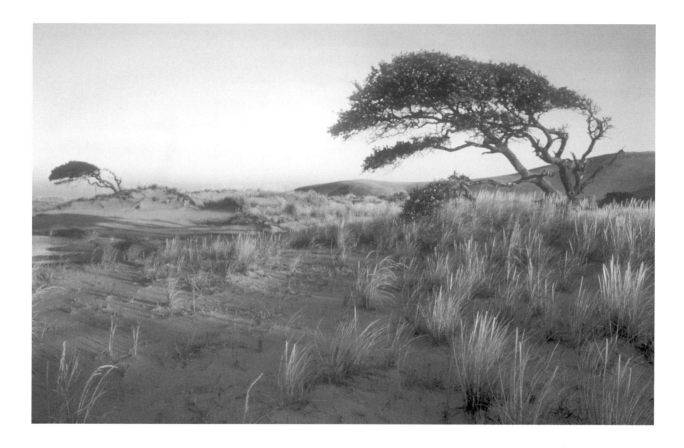

Windswept oaks and dunes near
Jockey's Ridge at Nags Head.

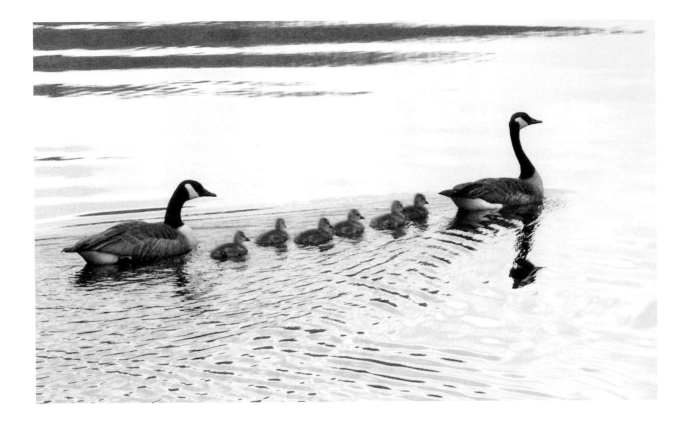

Wild Canada geese with newly
hatched goslings.

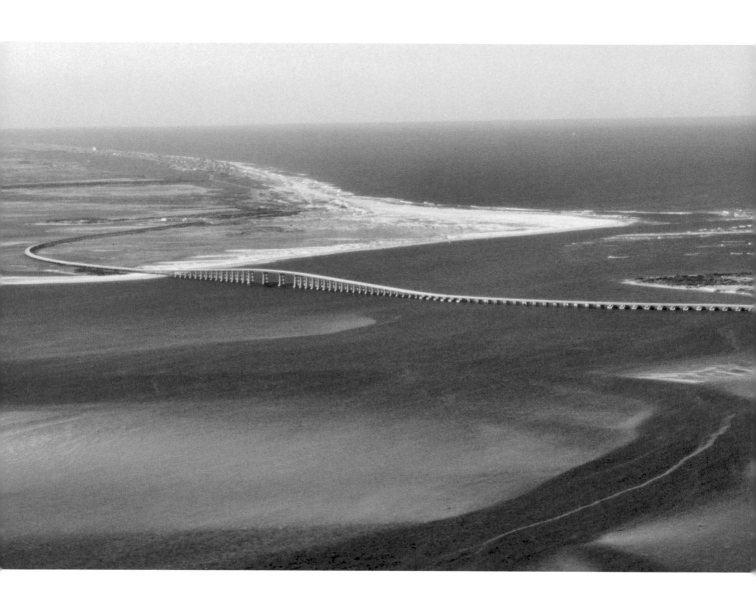

Oregon Inlet and the Bonner bridge between Bodie Island and Hatteras Island on the Outer Banks. Oregon is more an outlet than an inlet, and much of the runoff from northeastern North Carolina flows beneath the bridge, contributing to a continuous buildup of shoals.

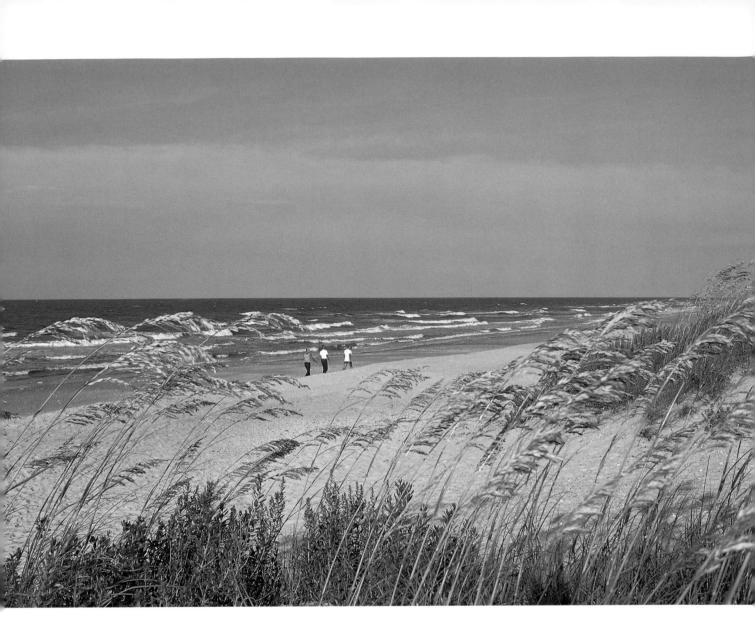

Sky, surf, sand, and sea oats.
In those four items we have the
essential elements of North
Carolina's fine beaches.

opposite:
Cape Lookout Lighthouse.
Completed with a natural brick color
in 1859, Lookout Light was painted
with its diamond daymark pattern in
1873 to distinguish it in daylight hours
from lighthouses of similar design at
Bodie Island and Hatteras.

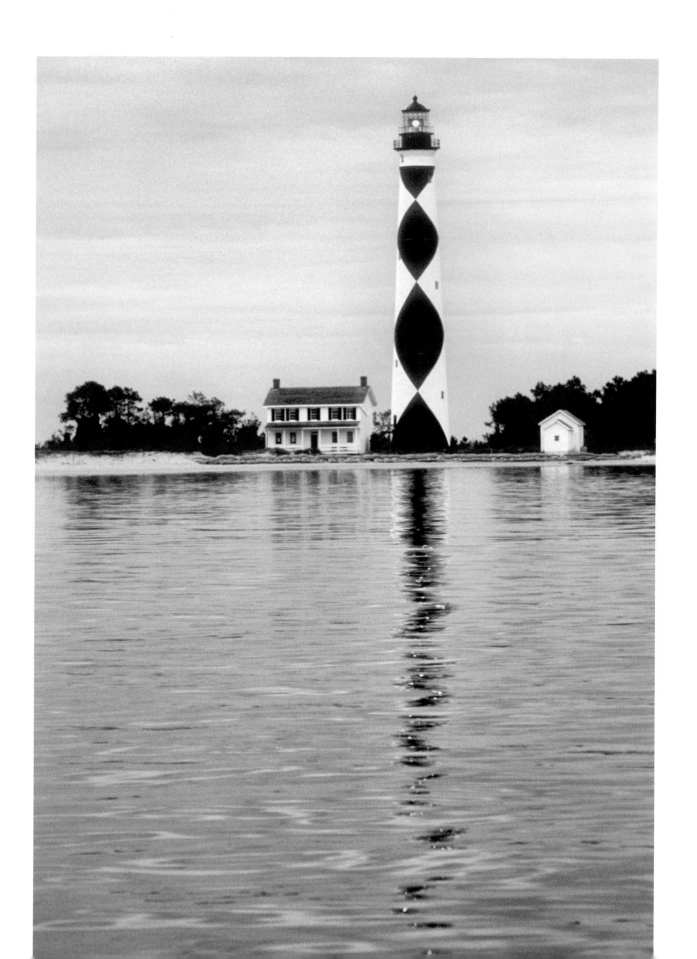

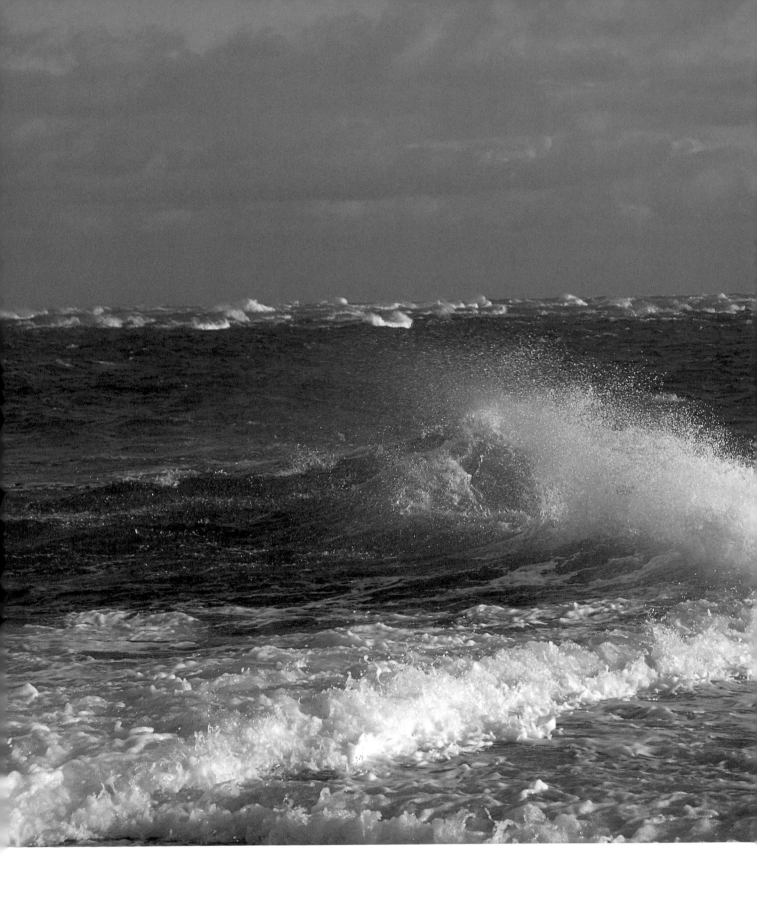

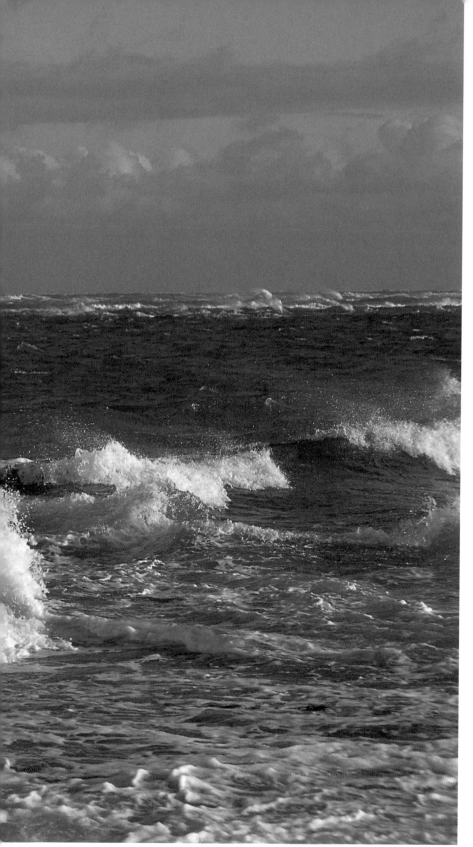

Turbulent breakers east of Cape Point at Hatteras. In the distance is the extremely violent area of surf called Diamond Shoals and the Graveyard of the Atlantic. The big slough between the two surf areas is calm by comparison, and it produces some of the finest surf fishing on the Atlantic coast.

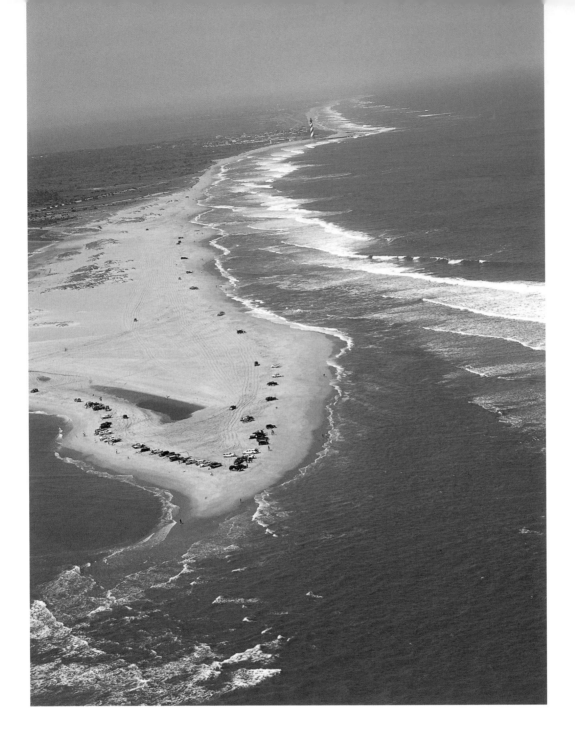

Cape Point, with the Cape Hatteras Lighthouse at its historic site in the upper part of this photograph, before it was moved half a mile inland. The three jetties in front of the lighthouse caused noticeable displacement of sand immediately south of the famous beacon, while old-time natives of the area believe sand has increased substantially to the south at Cape Point in the lower portion of the photograph.

People

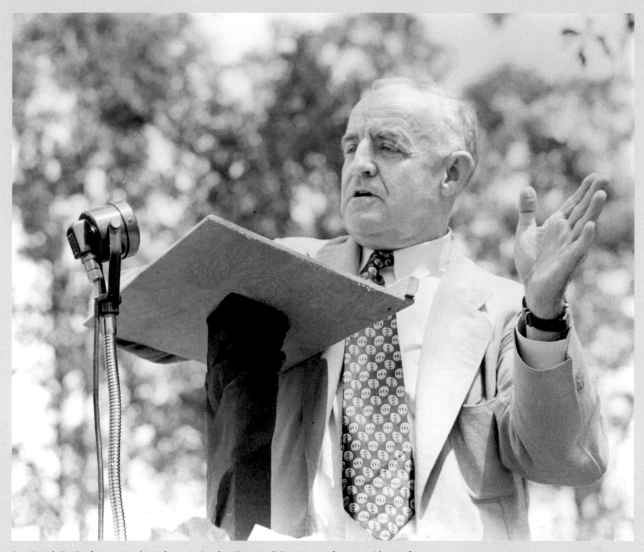

Dr. Frank P. Graham was best known in the Tar Heel State as a fine president of the University of North Carolina. Those of us who knew him believed Dr. Graham would be the best possible next-door neighbor, but he was no pushover. John Ehle's book *Dr. Frank* relates that the fearsome labor leader John L. Lewis was threatening a national coal strike in November 1941 while our country was supplying arms to France and Britain in the battle of our lives against Hitler. Dr. Graham negotiated with John L. for the National Defense Mediation Board (later reconstituted as the National War Labor Board after America entered the war), and there was no strike. Lewis was heard to say to an aide, "Who locked me in with that sweet little son-of-a-bitch?" Another observer in the hallway following the negotiation heard Lewis say, "Now be careful with that little sob, Graham; he'll lean across the table, stick his little chin out, and ask you for your shirt and make you think you owe it to him."

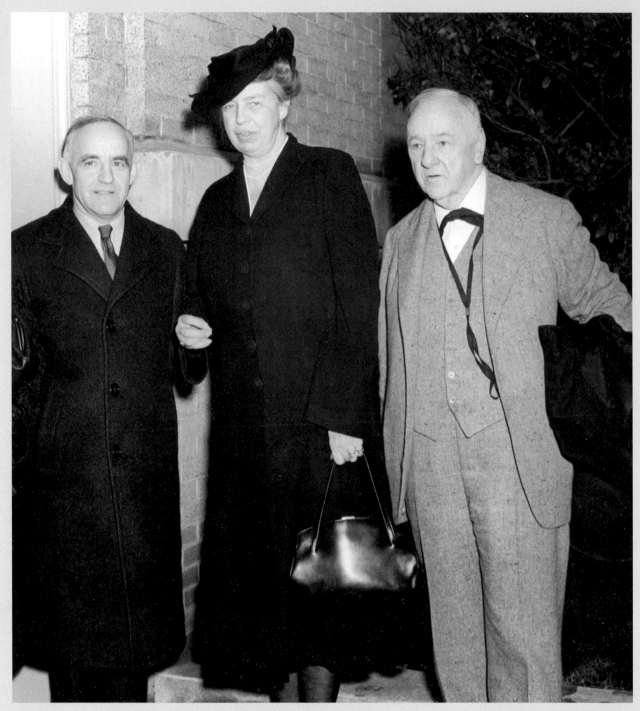

UNC president Frank P. Graham (left) was proud host to First Lady Eleanor Roosevelt and Josephus Daniels, publisher of the *Raleigh News and Observer*, as they stood at the stage entrance of Memorial Hall in Chapel Hill prior to an address by Mrs. Roosevelt. Josephus Daniels was secretary of the navy in World War I, when the assistant secretary of the navy was Franklin D. Roosevelt.

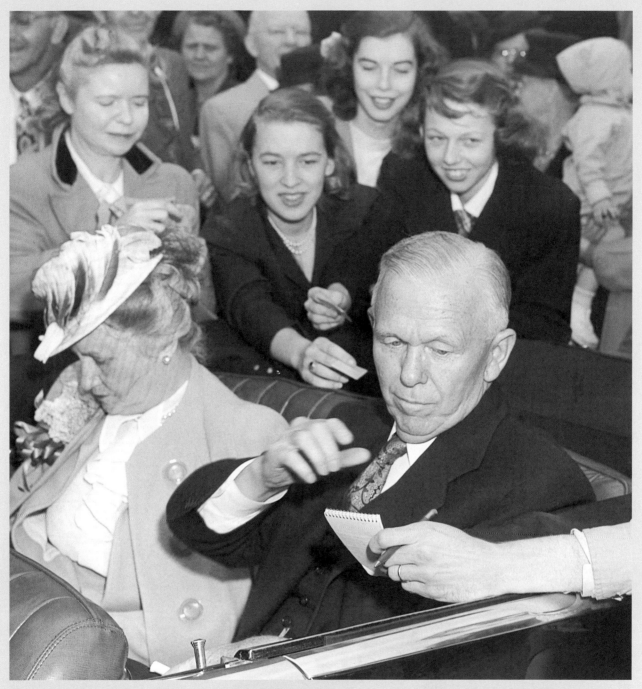

The top military leader for the United States in World War II was five-star general George C. Marshall. When General and Mrs. Marshall made their retirement home in Pinehurst, North Carolinians could not have been more pleased. This photograph of General and Mrs. Marshall was made as they rode in the April 1949 Azalea Festival Parade at Wilmington, where their hosts were their longtime friends, Bishop and Mrs. Thomas H. Wright.

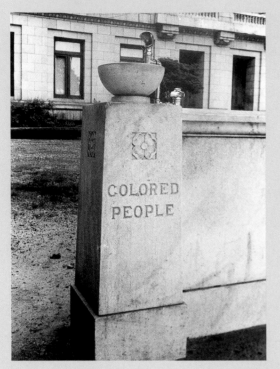

I have difficulty believing I made this photograph as recently as I did, which was June 1957 in front of the Wake County Courthouse. As this photo illustrates, separation of the races in that era was indeed "engraved in stone." We can all be grateful that the edifice of segregation was pulled down as quickly as it was once it was challenged in the 1960s.

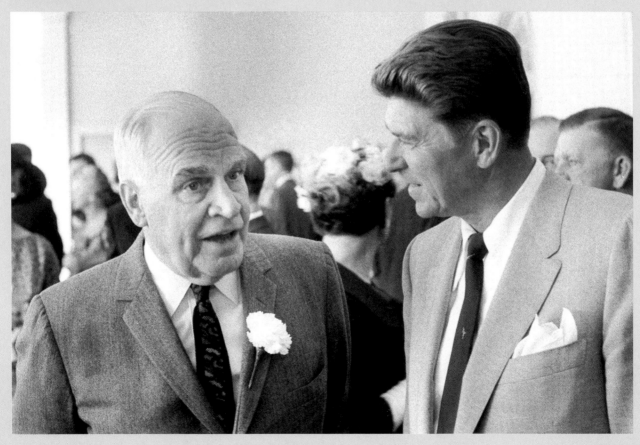

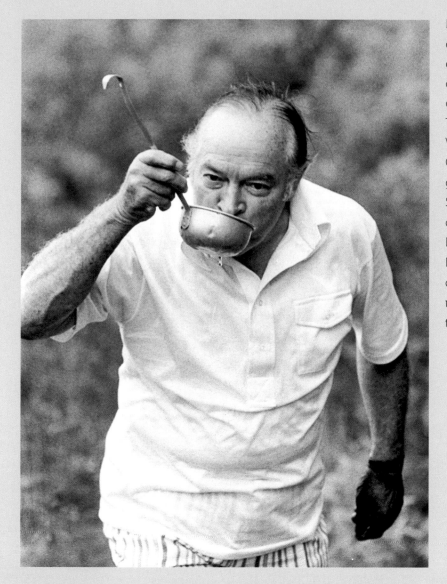

Bob Hope (shown here in 1966) died at age 100 in July 2003. The flag on top of Grandfather Mountain flew at half staff, for we believed Bob was one of our country's greatest citizens. Twice Bob visited General William Westmoreland at Grandfather Country Club, and the only time Bob left the golf course was to speak at the 1974 Singing on the Mountain. I was an army photographer assigned to cover Bob Hope entertaining troops in the Pacific in World War II. Riding in the car with him from military base to military base gave me the happiest two days of my three years at war.

opposite:

The reception in the ballroom of Cape Fear Country Club was a mob scene, so I asked Governor Luther Hodges and azalea ball master of ceremonies Ronald Reagan to let me photograph them in relative quiet on the sunporch. Reagan knew that Hodges had been in charge of twenty-nine Marshall Field mills all over the world. He asked the governor how he felt about being in public service after having been important in business. Hodges responded that all successful businesspeople are obligated to render public service. Reagan kept asking leading questions, and Hodges kept supplying persuasive answers. I have always thought that Hodges was a major influence on Reagan's launching a political career.

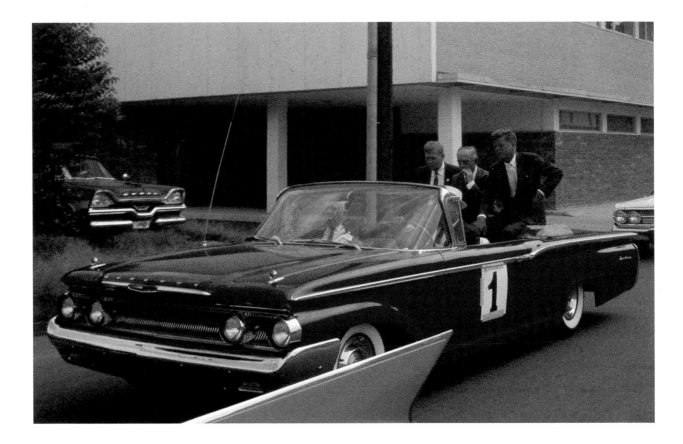

Seated above the backseat of
the flashiest red Mercury convertible
available in 1960 were, left to right,
Democratic nominee for governor
of North Carolina Terry Sanford,
Congressman Herbert Bonner, and
U.S. Senator John F. Kennedy. They
were in the number one car of the
Greenville, N.C., parade honoring
Senator Kennedy's campaign for
president.

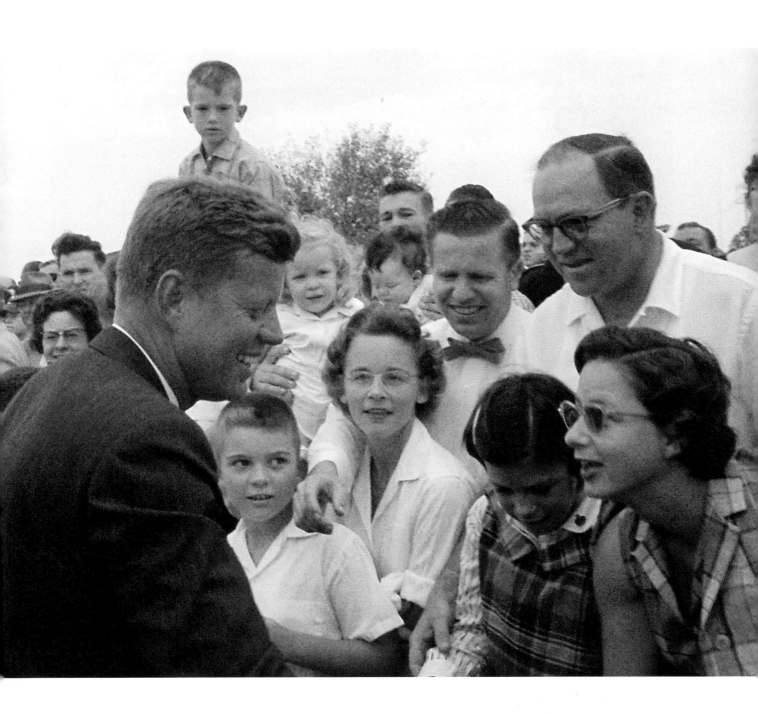

U.S. Senator John F. Kennedy was given a warm reception by the crowd assembled in Greenville, N.C., for his speech in his 1960 campaign for president.

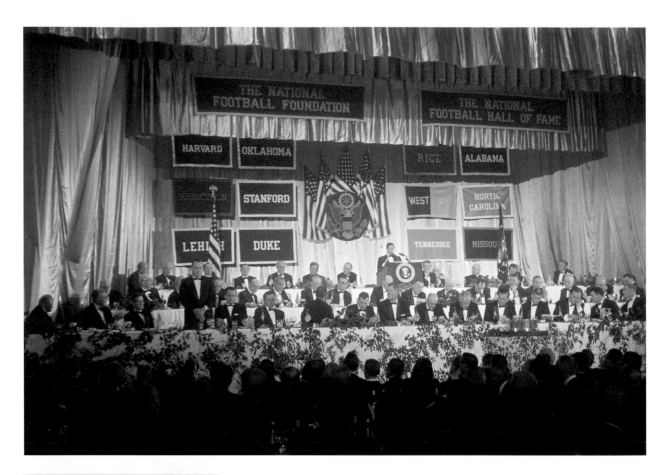

top:

In December 1961 Charlie "Choo Choo" Justice was taken into the National College Football Hall of Fame in an impressive ceremony at the Waldorf-Astoria Hotel in New York. Charlie is shown standing as the citation of his accomplishments is read at the rostrum. Among those at the head table were Bob Hope, President John F. Kennedy, and General Douglas MacArthur. President Kennedy had the responsibility of following Bob Hope as a speaker, an assignment too cruel to be given to anybody.

bottom:

Aycock Brown, writer-photographer who put the beaches of northeastern North Carolina on the map, was appropriately called "The Barker of the Banks." Another great publicist, Bill Sharpe, said Aycock was not necessarily the best writer or photographer, but that Aycock was aware of the secret of the profession: Aycock knew to take the mail to the post office.

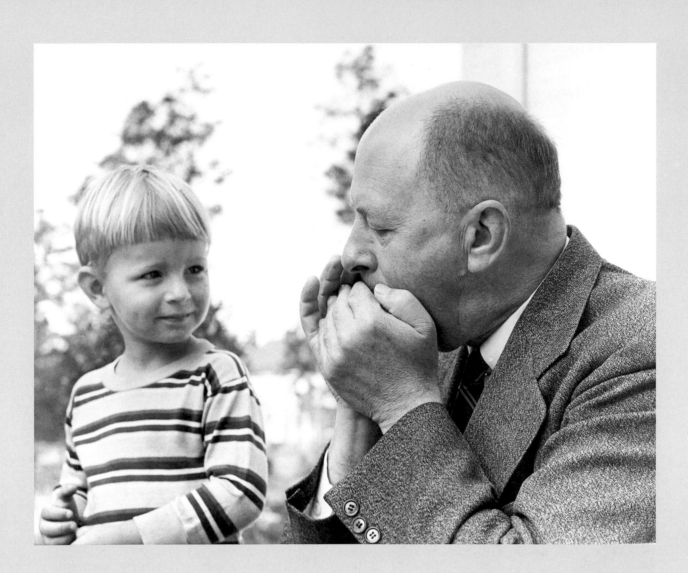

Robert House, the beloved
chancellor of the University of
North Carolina, was an overnight
guest in the Morton household when
he spoke to the Wilmington chapter
of Carolina alumni. Chancellor House
usually referred to his "notes" in his
speeches; young Hugh Morton Jr.
thought the mouth organ "notes"
of "Oh! Susanna" were great.

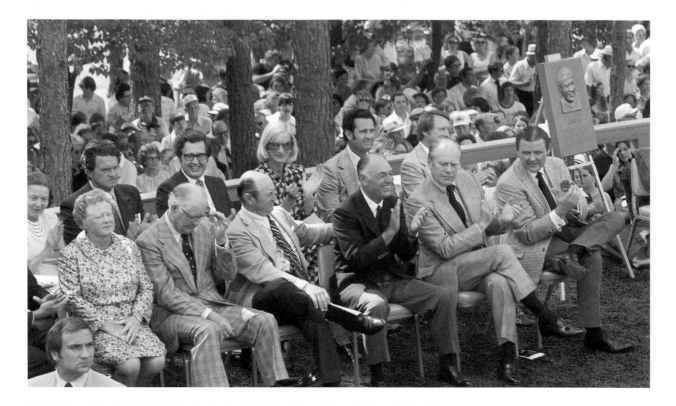

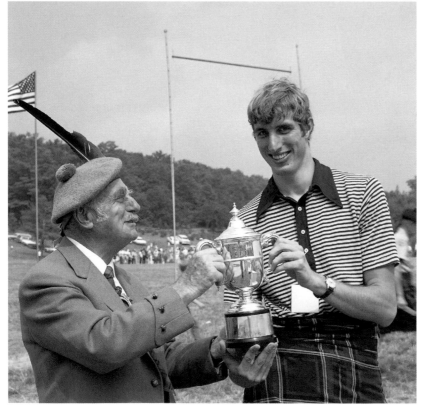

top:

The day the Golf Hall of Fame was dedicated in Pinehurst in 1974, the front row included among its celebrities, left to right, Patty Berg, Byron Nelson, Sam Snead, Ben Hogan, and President Gerald Ford.

bottom:

Highland Games president N. J. MacDonald handed the President's Cup to outstanding athlete Tony Waldrop at the 1973 Highland Games. Waldrop was ACC Athlete of the Year in 1974. He ran eleven consecutive sub-four-minute miles and set the world record for the indoor mile. He has three degrees from UNC-Chapel Hill, where he is vice-chancellor for research and development.

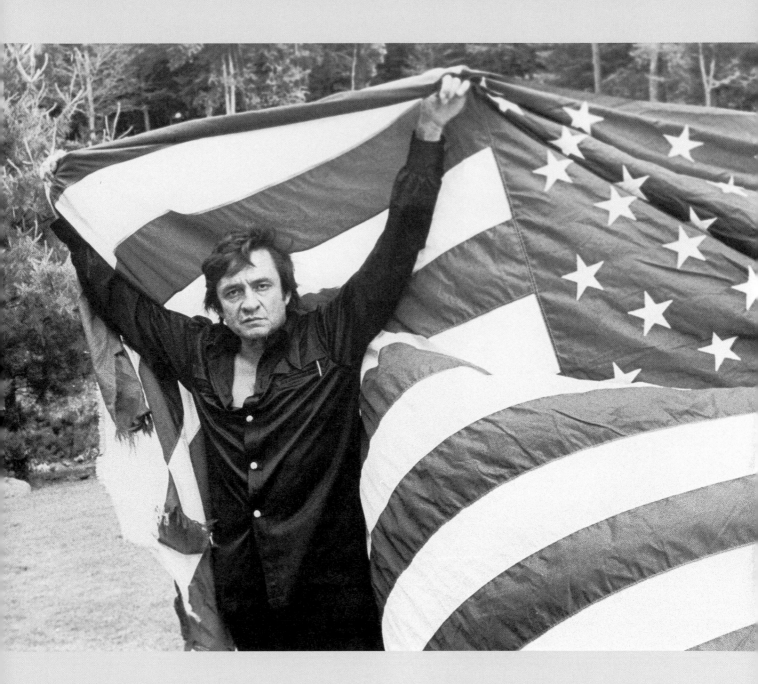

When Johnny Cash and I were walking across the Mile High Swinging Bridge, he saw the flag had been torn by the wind atop the visitor center. Johnny told me he had a patriotic song, "That Ragged Old Flag," and he asked for our most tattered one. We gave it to him. We were honored that henceforth Johnny Cash would be wrapped in Grandfather's ragged old flag each time he sang his song.

Coach Dean Smith and I have examined this January 1991 photograph closely, and we think Michael Jordan had enough strength in his right foot to be able to stay in bounds as well as keep control of the ball. Kendall Gill (13) of the Charlotte Hornets and, more importantly, the official in the background might disagree.

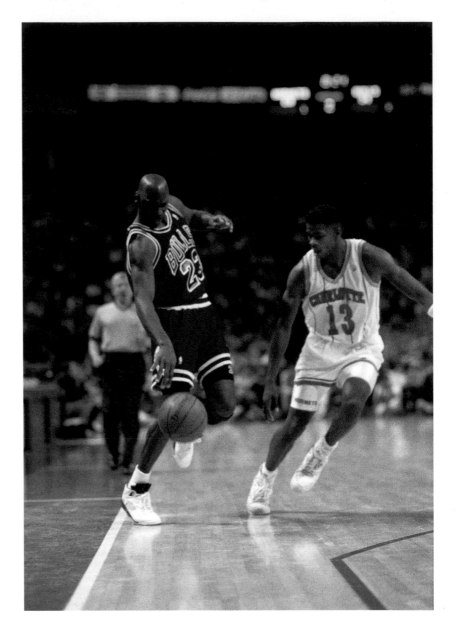

opposite:
The costumed ram at Chapel Hill has never made a youngster more happy than when the January 1988 ram gave his full attention to this young gentleman. We did not get the boy's name, but we are glad to have the picture.

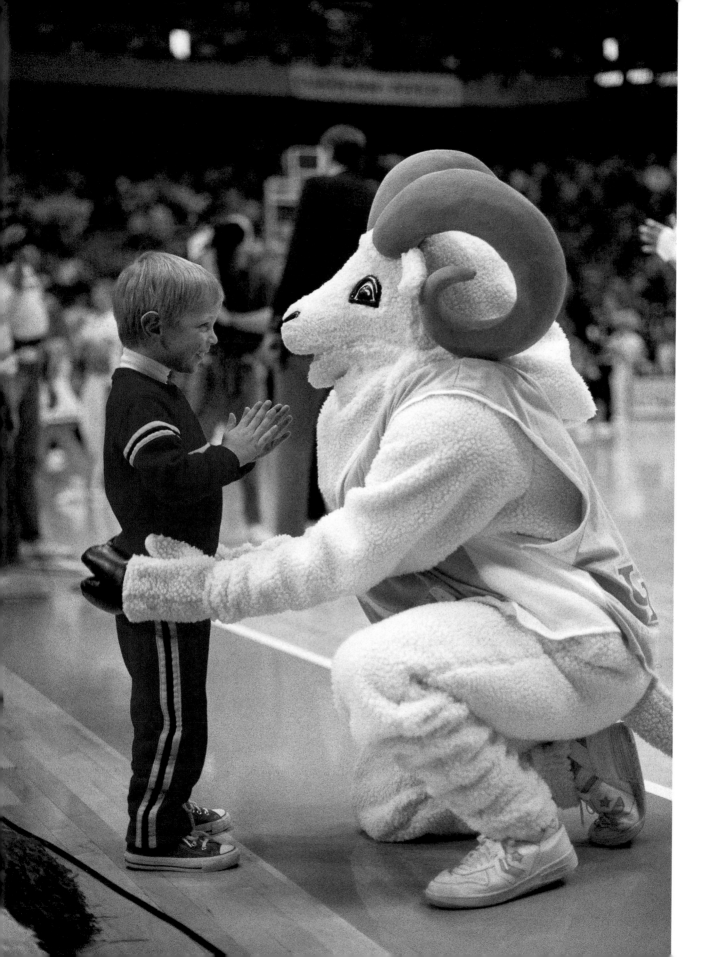

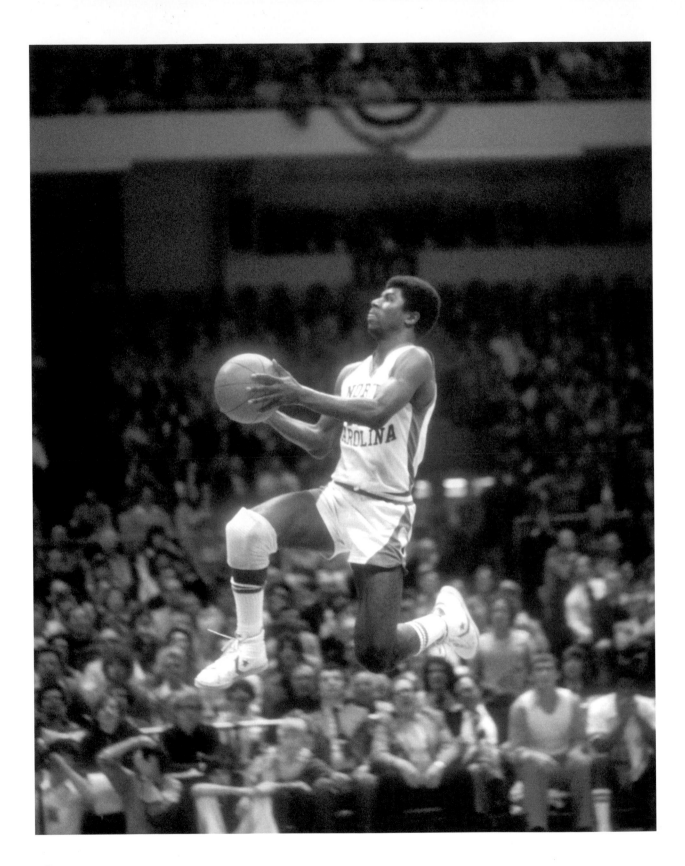

Mia Hamm won nearly every athletic award a woman soccer player can win in the ACC and NCAA. She was three times consensus All-American and an Olympic gold medalist in 2004. Few would argue that Hamm is not the best-known and most talented woman athlete who ever attended the University of North Carolina. *People Magazine* named her one of the 50 Most Beautiful People in the World in 1997.

opposite:
Phil Ford scored more points than any other basketball player for the University of North Carolina. He was two times All-American and National NCAA Player of the Year. Later, he was assistant basketball coach for Dean Smith at Carolina and for the Larry Brown–coached pro team that many called the Carolina Pistons (since most of Brown's coaching staff, plus a star player, were from Chapel Hill).

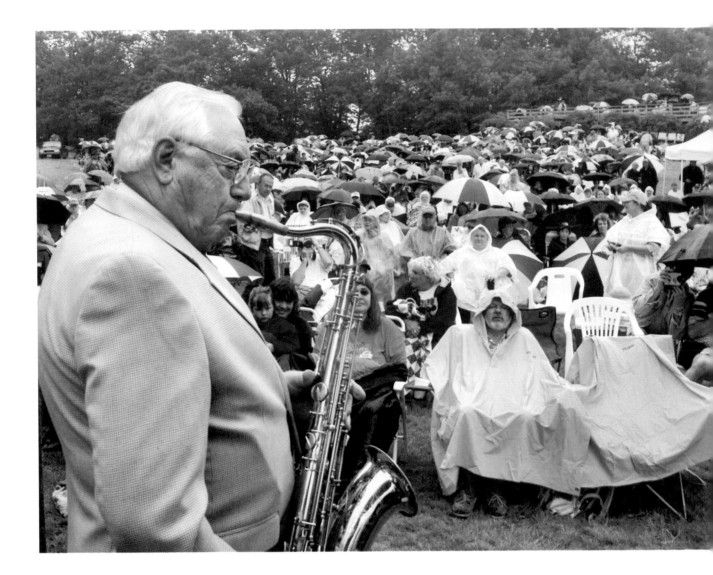

Boots Randolph, the world-famous saxophone player from the swing band era, also plays gospel. At the 2005 Singing on the Mountain, in the pouring rain, Boots played old-time favorites like "Just a Closer Walk with Thee," "Will the Circle Be Unbroken," and "When the Saints Come Marching In." Out in front of him under thousands of ponchos and colorful umbrellas were people who did not seem to mind the downpour.

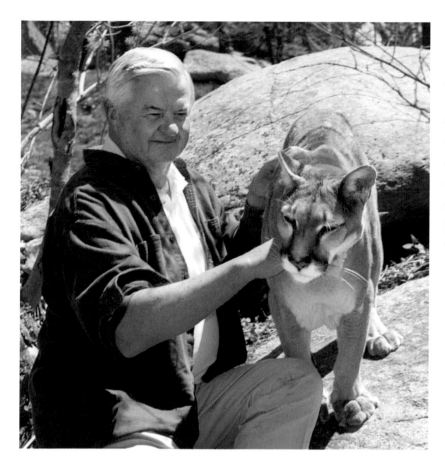

Carolina Panthers owner Jerry Richardson is justly proud of his black panther logo, but I told him that if he would come to Grandfather Mountain, we would photograph him with a tan-colored panther once native to the Carolinas. Jerry was at Grandfather the next week. Two of our panthers are pretty aggressive, while another one was raised as a house pet, so we used that one. No blood was shed.

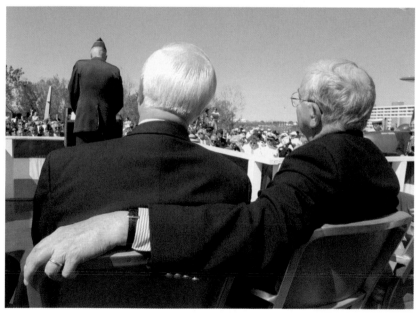

Two political rivals, Senator Jesse Helms (right) and Governor Jim Hunt, had worked together on projects such as the Save Cape Hatteras Lighthouse Committee, so it was not unreasonable that they should sit together in friendly fashion at the Battleship Memorial in Wilmington. They were listening to General Hugh Shelton, chairman of the U.S. Joint Chiefs of Staff, speak at the fiftieth anniversary of the World War II program held on the deck of the ship that is a memorial to the 10,000 North Carolinians who died in World War II.

If any of us coached one person who became an All-American in track, we probably would be proud of ourselves. Dr. Leroy Walker, former chancellor of North Carolina Central University, coached 111 All-Americans, 40 national champions, 12 Olympic medalists, and 8 world-record holders. Furthermore, Coach Walker served a term as president of the U.S. Olympic Committee. We are mighty proud of Coach Leroy Walker and the athletes who responded to his coaching.

In 2003 the Reverend Franklin Graham undertook to head his father's Billy Graham Evangelical Association as well as his own Samaritan's Purse organization. The employee enlarged family picnic was moved to a tremendous tent in the middle of the Highland Games track. Counting kids, 1,139 people were there, including Dr. Billy Graham, who was pleased to see his and Franklin's faithful helpers having barbecue and a wonderful time at Grandfather.

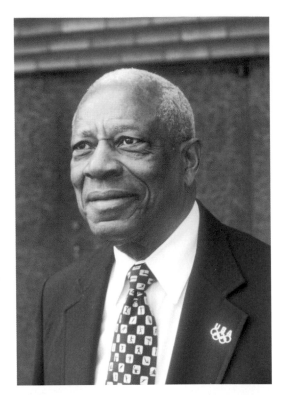

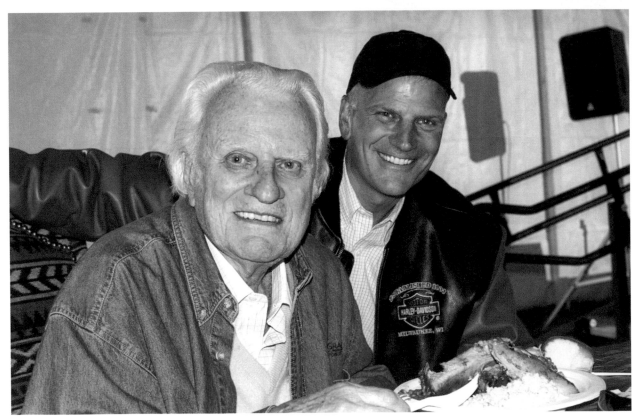

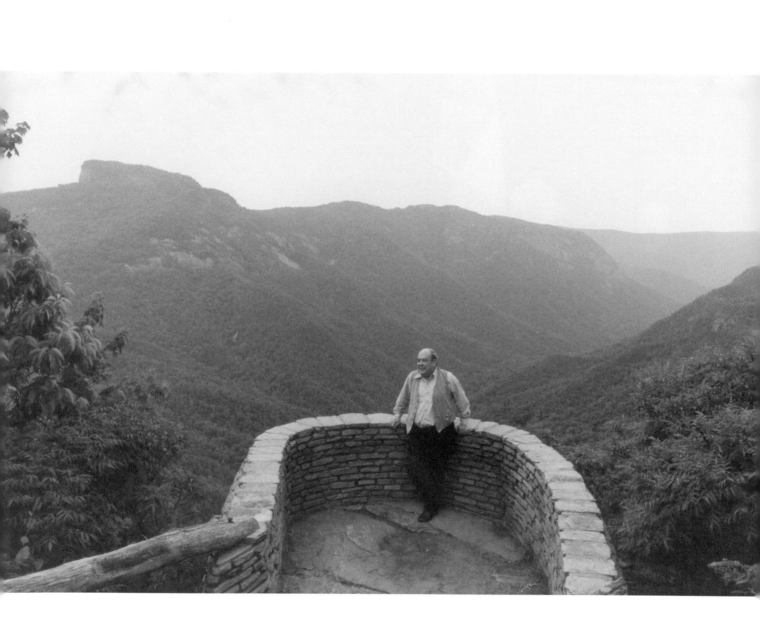

Lots of people love North Carolina, and Charles Kuralt was certainly one of them. Charles wrote the words and Loonis McGlohon wrote the music for "North Carolina Is My Home," the patriotic North Carolina musical number that is without equal. Here Kuralt is enjoying the grandeur of Linville Gorge from Wiseman's View.

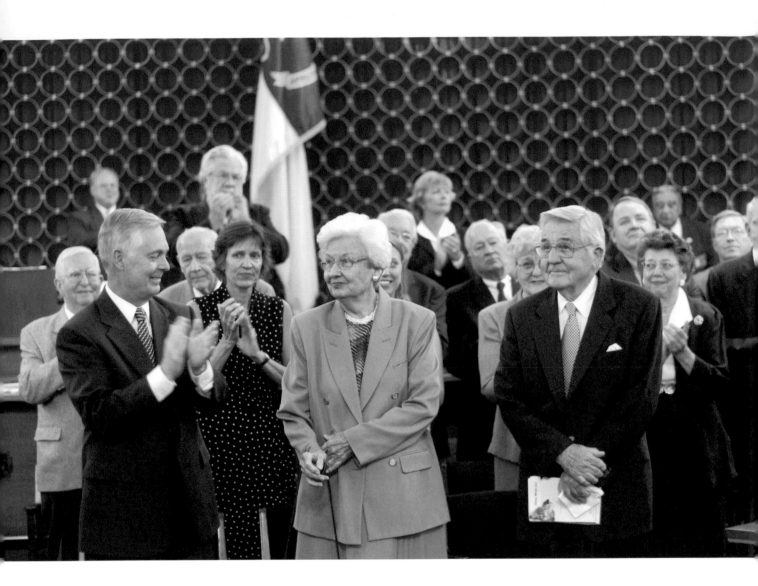

The North Carolina General Assembly has honored several of the state's distinguished citizens after they have died, but the service to the people of North Carolina of Bill and Ida Friday had been so outstanding that the general assembly decided they should be honored while living. That was done on the floor of the State Senate in 2004, with Governors Easley, Hunt, and Holshouser present, as well as members of both House and Senate and former members of the UNC Board of Governors.

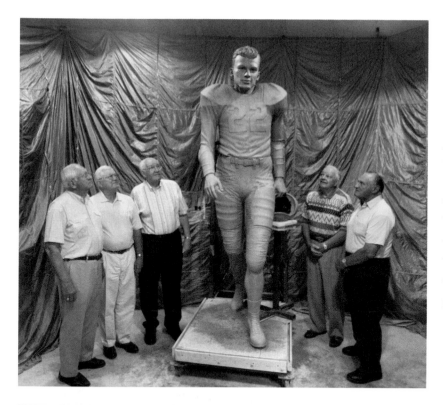

Before the bronze was cast for the eight-foot, six-inch statue of Charlie Justice, five of his former teammates viewed the clay model used to cast the bronze. The team members visiting the studio of sculptor Johnpaul Harris at Asheboro are (left to right) Joe Neikirk, center; Bob Cox and Art Weiner, ends; Walt Pupa, fullback; and Joe Wright, blocking back. Walt Pupa climbed a stepladder to reach the top of the clay model, and he called down to his teammates, "I have chills and goose bumps. I think I am looking at Charlie face-to-face."

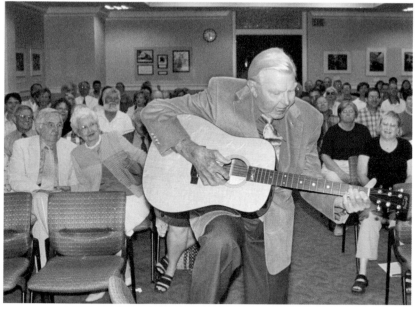

Andy Griffith, one of North Carolina's best-known native sons, announced in September 2005 that he is donating his *Andy Griffith Show* scripts and other memorabilia to the Southern Historical Collection and the North Carolina Collection at the University of North Carolina. Griffith is shown tuning his Martin guitar, one of the memorabilia gifts he included, during a special ceremony before historians and librarians at UNC's Wilson Library in Chapel Hill.

top:

Frank Borman was commander of the first spaceship to circle the moon, and he snapped the picture I think is the greatest photograph of all time that shows the earth above the surface of the moon. In the mid-1970s, Borman was a guest at our neighbor's home next door. He joined my dog and me for a trip up Grandfather. About halfway up Frank said, "My ears are popping." Then we broke out laughing. Here was the first man to circle the moon, and his ears were popping driving up Grandfather Mountain.

bottom:

Three sainted persons in Duke University athletics — (left to right) Eddie Cameron, Wallace Wade, and Ace Parker — were at midfield in Wade Stadium as Parker presented his National Football Hall of Fame trophy to Duke University. The name of Ace Parker is held in the same reverence at Duke as the name of Charlie Justice is respected in Chapel Hill.

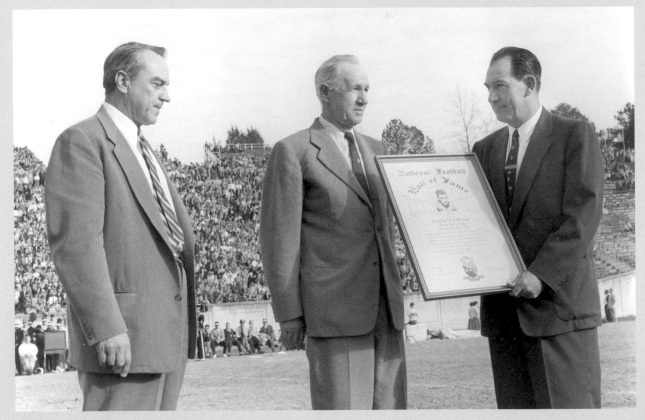

Erskine Bowles was chosen by unanimous vote of the university Board of Governors to be president of the University of North Carolina System. Bowles's background in the financial world, as well as his experience as White House chief of staff and his working with Democrats and Republicans in Congress to balance the U.S. budget, makes him uniquely qualified to administer the large university system. An avid sports fan, Bowles has a number of teams to root for with his responsibilities to sixteen campuses.

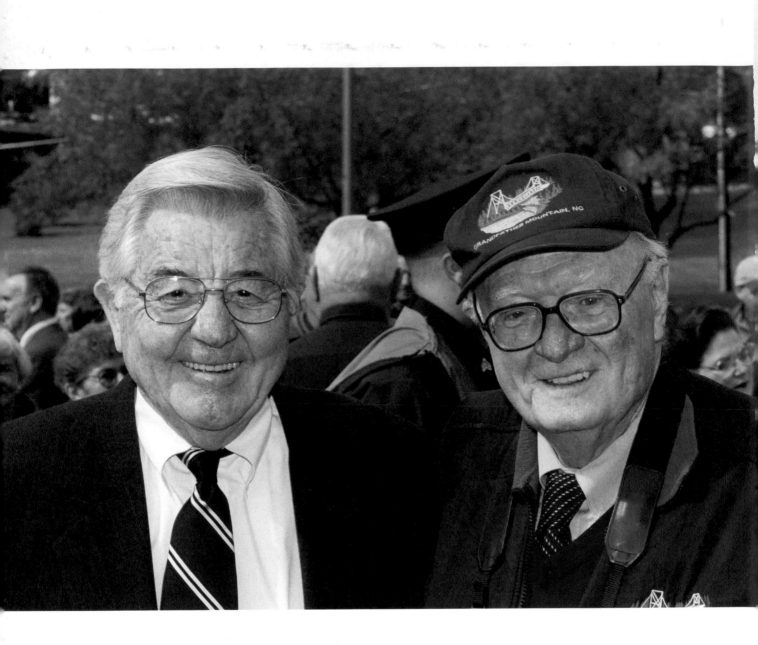

William Friday and Hugh Morton
at the dedication of the Andy Griffith
Parkway near Mt. Airy, 2002.
Photo by Gary York.